UNLEASHED

Library of Congress Cataloging-in-Publication Data available.

ISBN 978-1-4521-5764-1

Manufactured in China

Designed by Emily Dubin

Typeset in Canvas Curly Sans and Brandon Grotesque

10 9 8 7 6 5 4 3 2 1

Chronicle Books LLC
680 Second Street
San Francisco, California 94107
www.chroniclebooks.com

UNLEASHED

Amanda
Jones

CHRONICLE BOOKS

SAN FRANCISCO

FOR CHRIS

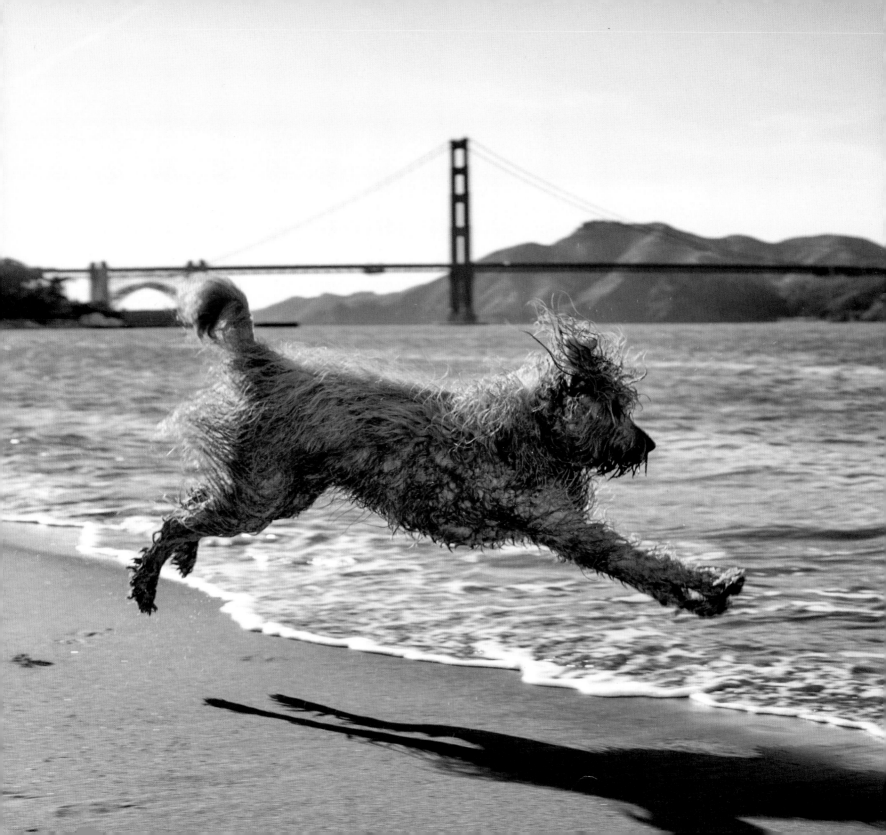

INTRODUCTION

The feeling of finally getting out of the crate after a day home alone. Or finally arriving at the beach after a three-hour car ride.

The human equivalent might be taking off on a plane for a faraway place you've never seen, hitting the open road for a week of exploring, or diving into the ocean for the first swim of the season.

A new start, fresh and exciting. Freedom! These are the sensations I tried to capture in *Unleashed*—images of sheer, unbridled joy the moment the leash is unhooked from the collar. This project represents a marked departure from the controlled setting of a studio, a place I had grown accustomed to after twenty years of photographing dogs. No longer was I able to regulate lighting or get the subject perfectly positioned. Gone too was the control of external forces like driving rain, falling snow, whistling wind, and distracting sounds. The absence of a seamless background in an air-conditioned studio revealed a world of intense textures: soft fur against a scrubby background, filtered light peeking from behind the clouds. Wet dogs. Dirty dogs. I loved it!

While photographing dogs across the country, I sometimes slipped out of the studio and captured my subjects in their natural element. Along the way, I kept an eye out for striking locations, vivid colors, and dramatic weather. I also asked locals about their favorite views and dog-friendly places. With my cameras, some treats, and a ball (always a ball), I headed outside.

After choosing my location, I set a physical boundary where I could create the images. Letting the dog run wild and untethered while trying to get them perfectly positioned was the true challenge. The ultimate reward was capturing the dog's beauty once poised in that ideal spot.

What I found was that from the heavenly Fort Funston in San Francisco to my home hills of Berkshire County, Massachusetts, there are endless fantastic outdoor opportunities to get out with your dogs. So what are you waiting for? Now's the time to hike that new trail together or see what's down by the river.

Now's the time to unhook the leash and GO!

Amanda Jones

SPRING

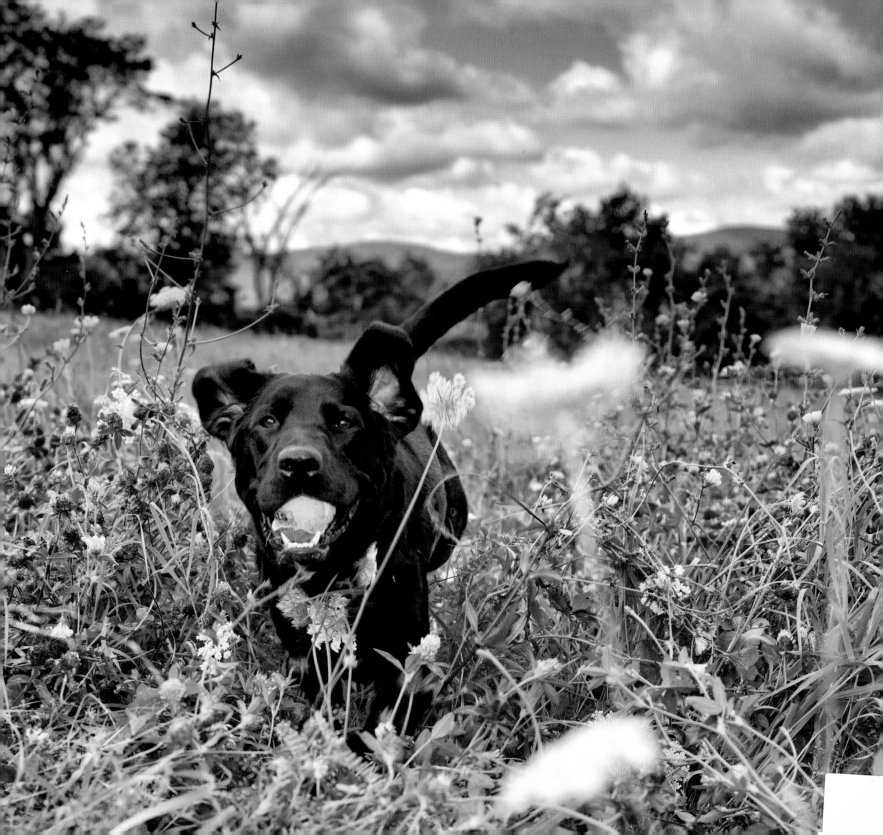

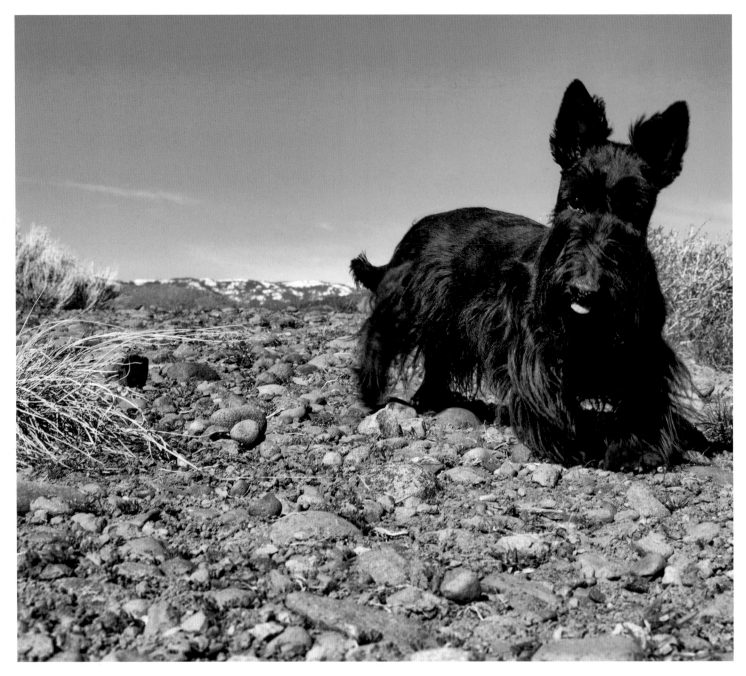

CARLY • Scottish Terrier • Reno, NV

DEPOT • Labrador Retriever • Williamstown, MA (previous)

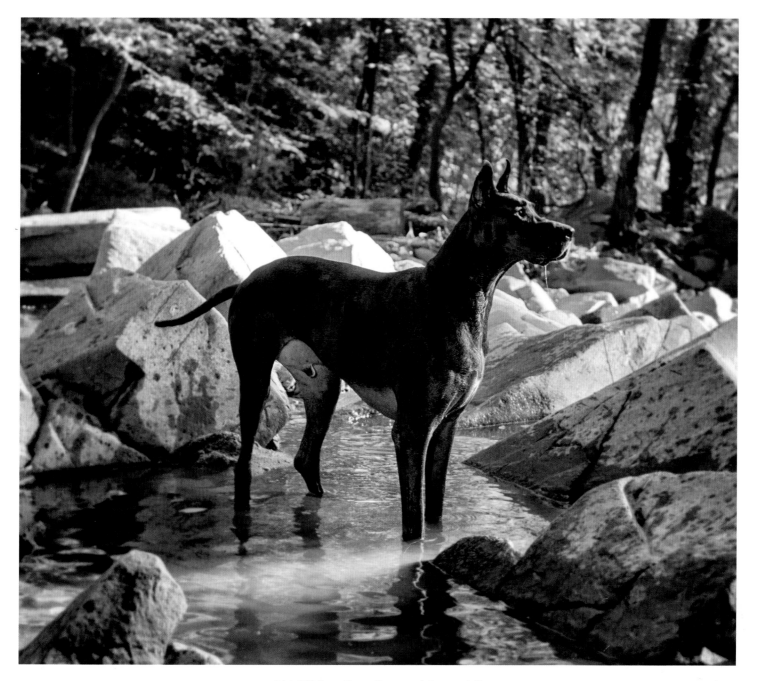

MACHO • Great Dane • Arlington, VA

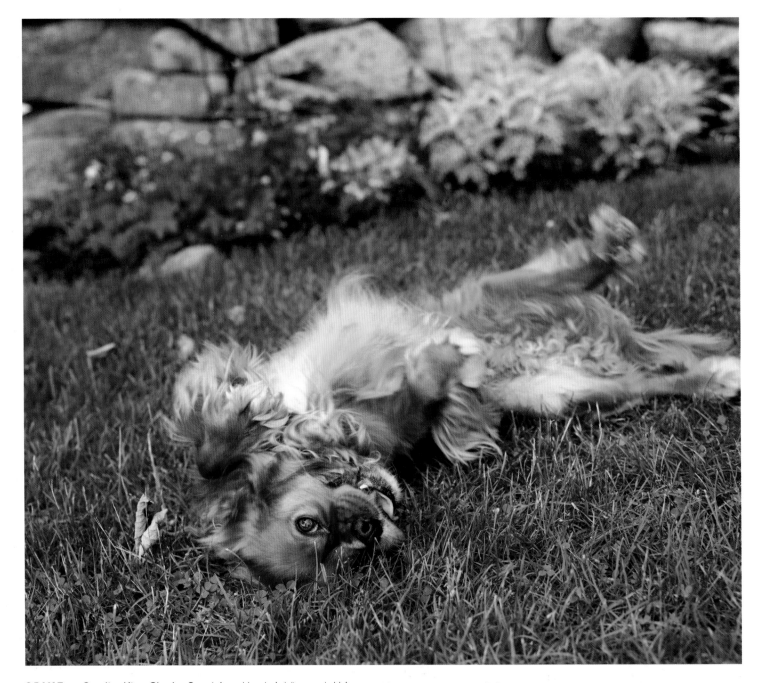

SPIKE • Cavalier King Charles Spaniel • Martha's Vineyard, MA

LIAM • West Highland Terrier • Boulder, CO (opposite)

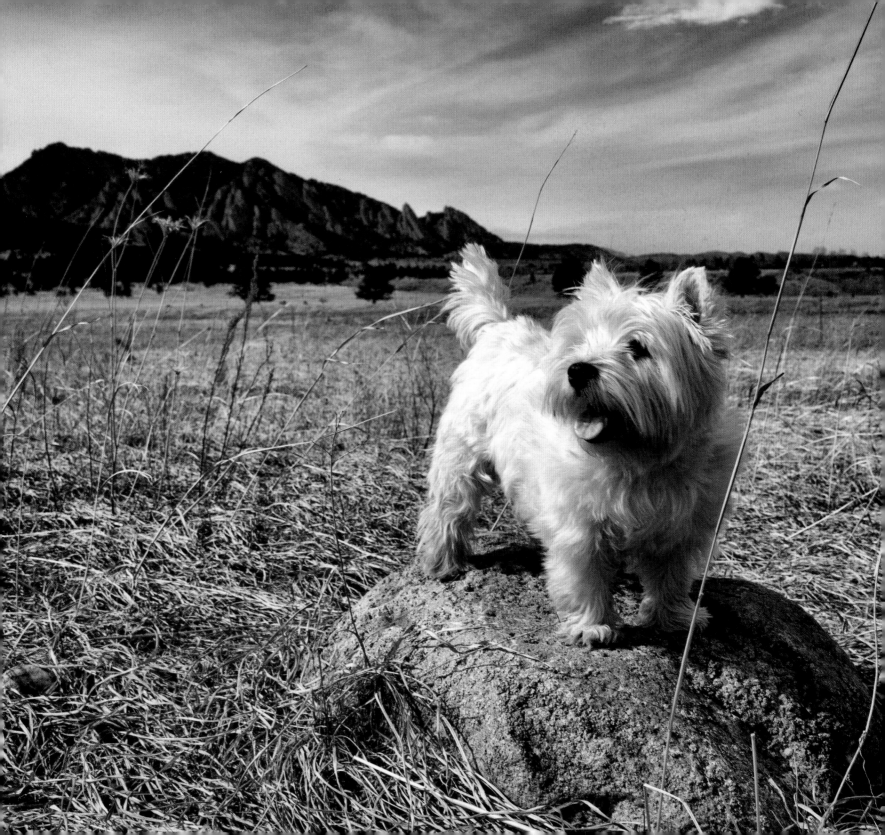

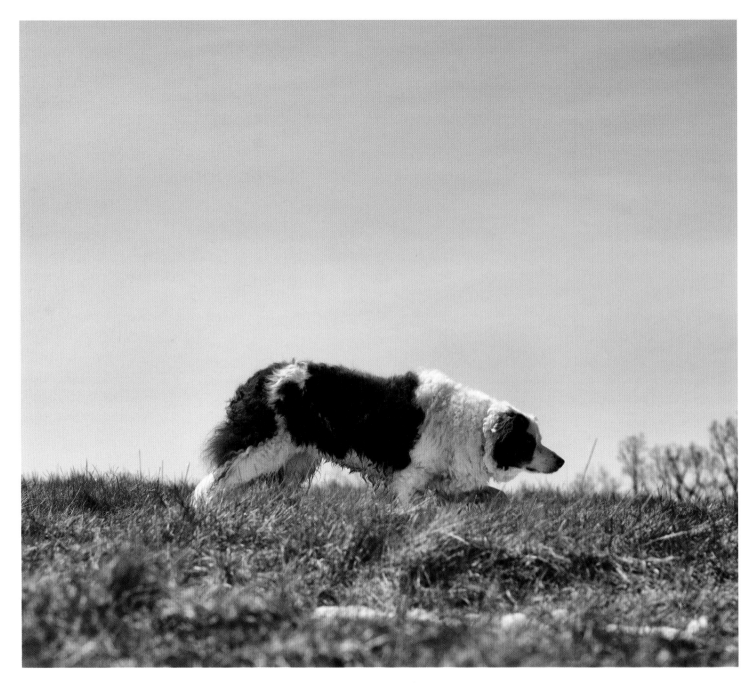

LASSIE • **Border Collie** • Black Earth, WI

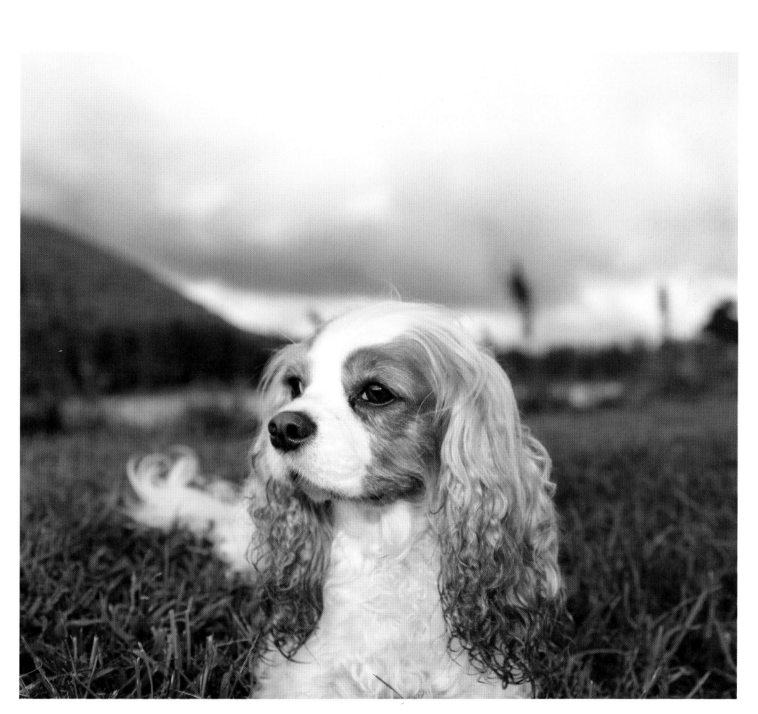

SOPHIE • Cavalier King Charles Spaniel • North Adams, MA

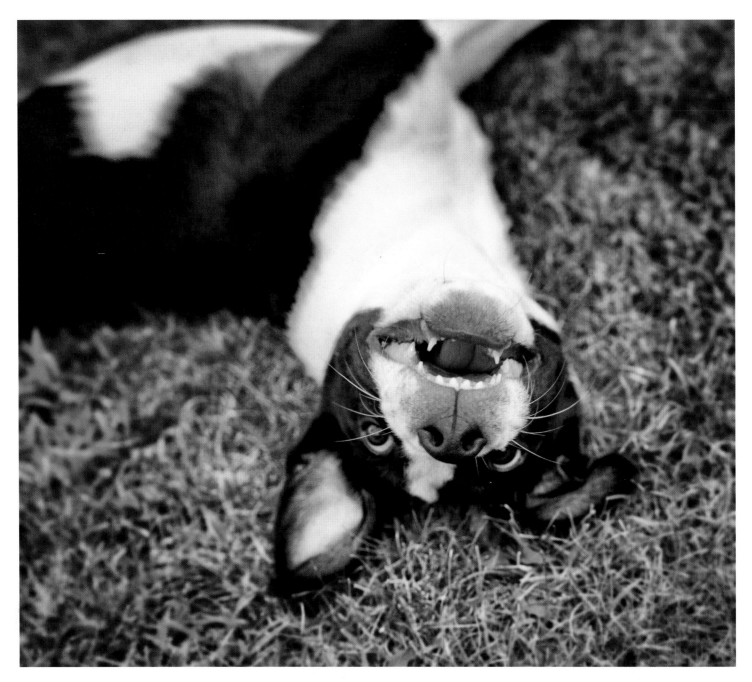

MAISY • **Mixed Breed** • North Adams, MA

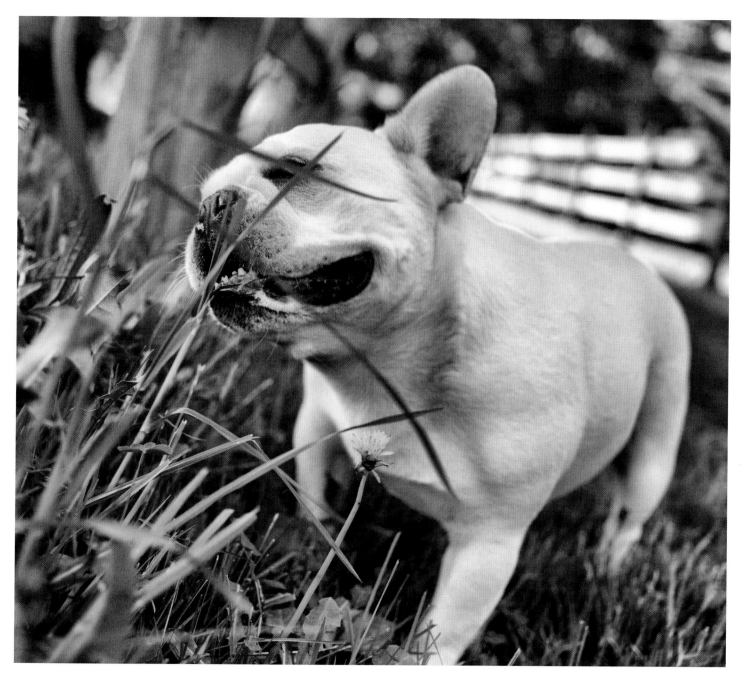

BUTTER • French Bulldog • Tamworth, NH

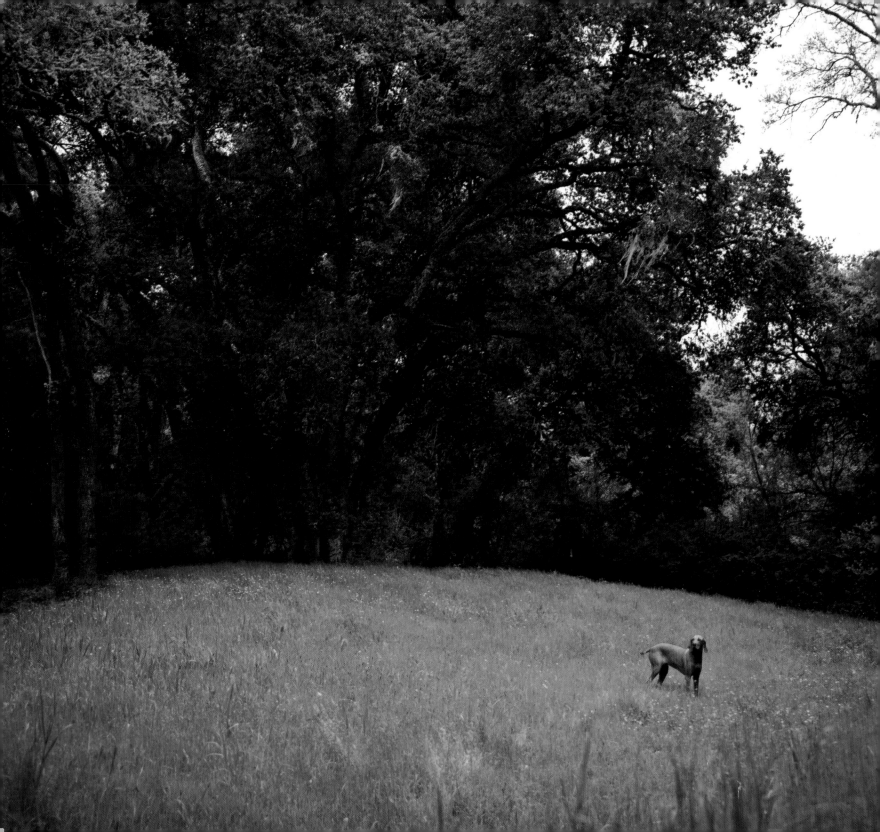

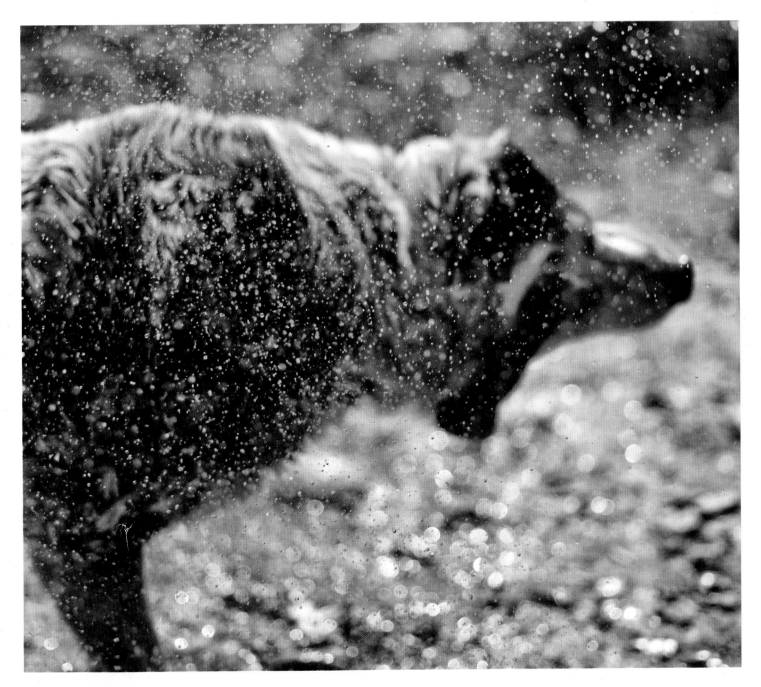

FELIX • Australian Shepherd • Williamstown, MA

SIERRA • Vizsla • Portola Valley, CA (opposite)

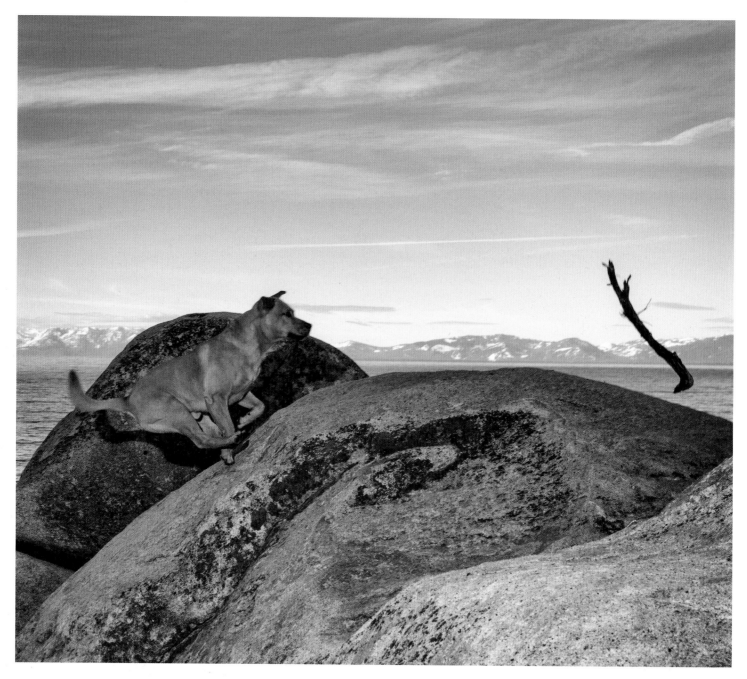

RA • Black Mouth Cur • Incline Village, NV

LADYBIRD • German Shorthaired Pointer • Lake Tahoe, NV (opposite)

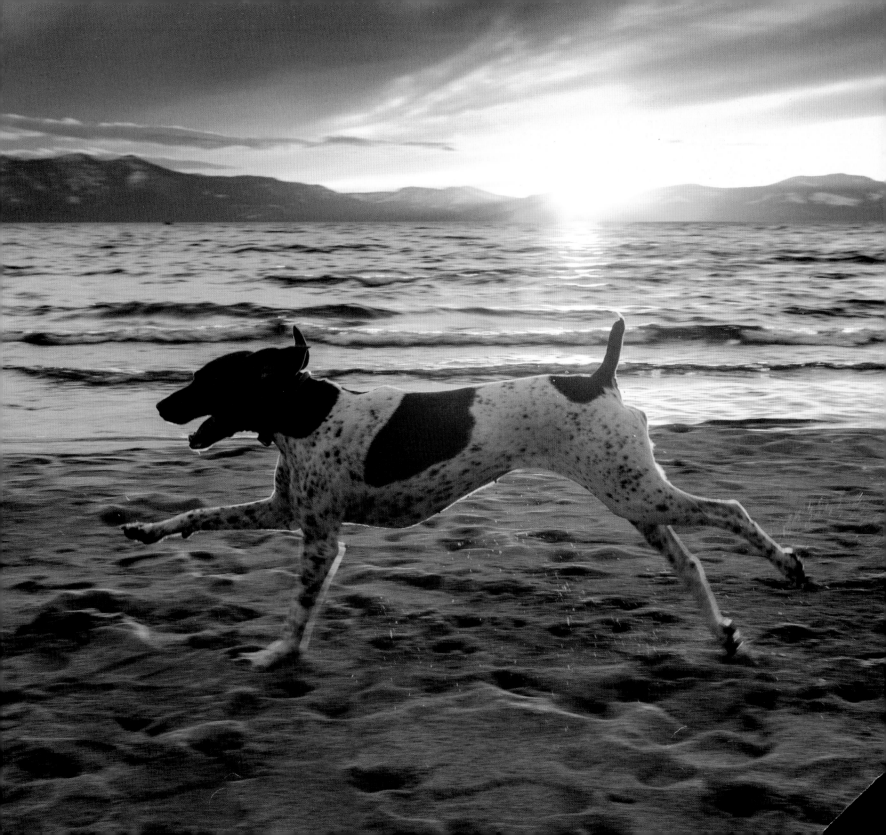

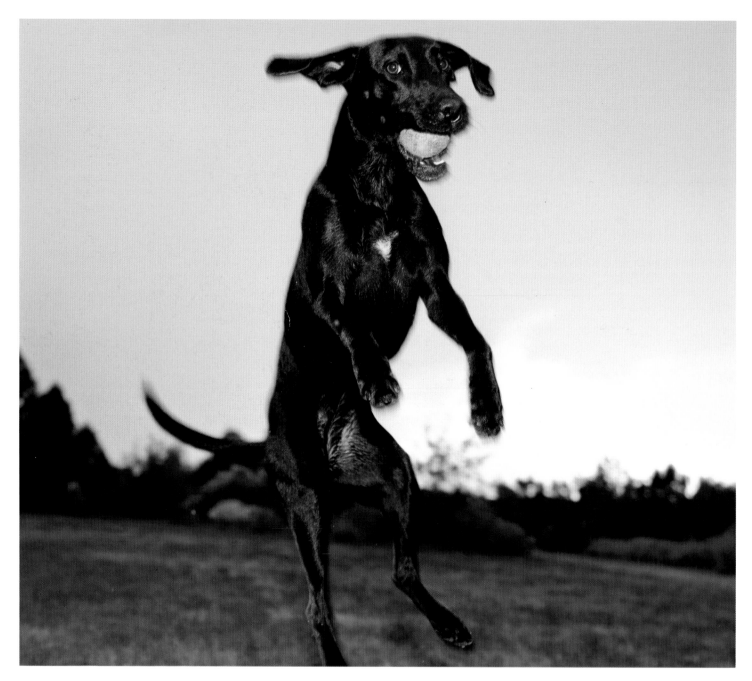

MARIAH • Mixed Breed • Boulder, CO

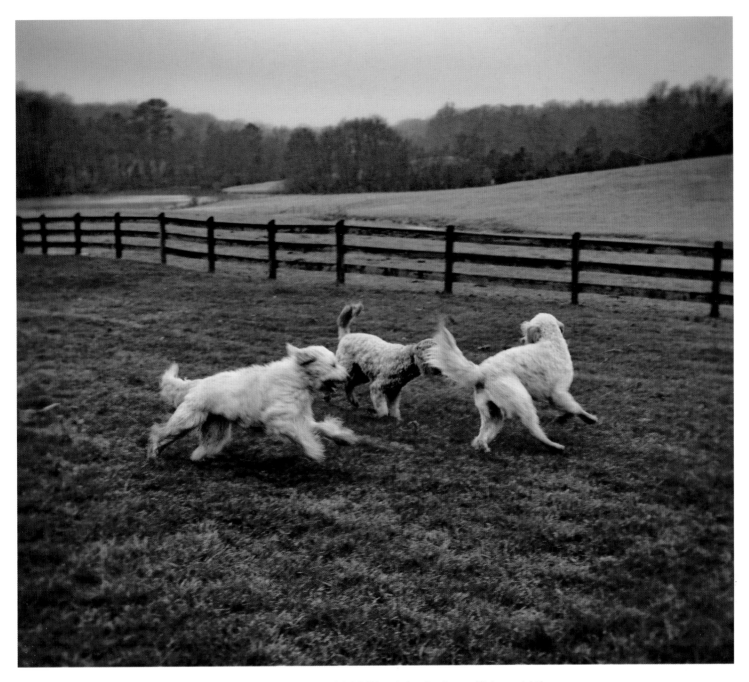

LIZZIE, MAGGIE & CALLIE • Labradoodles • Richmond, VA

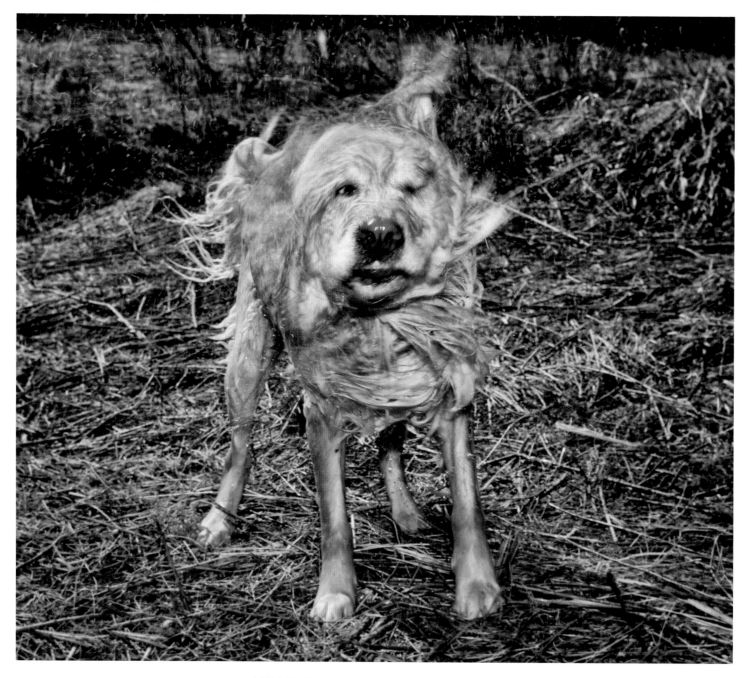

LIZ LEMON • Golden Retriever • Vestal, NY

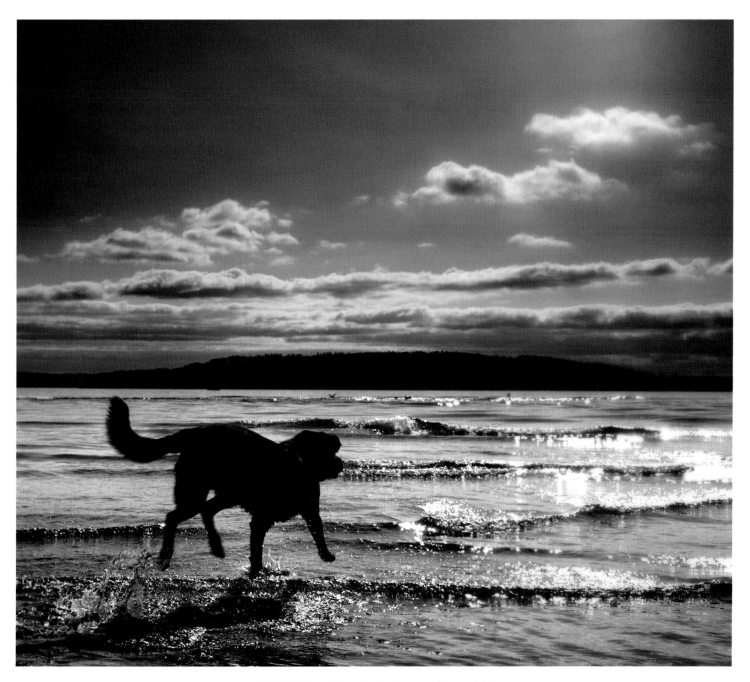

GEORGE • Labrador Retriever • Seattle, WA

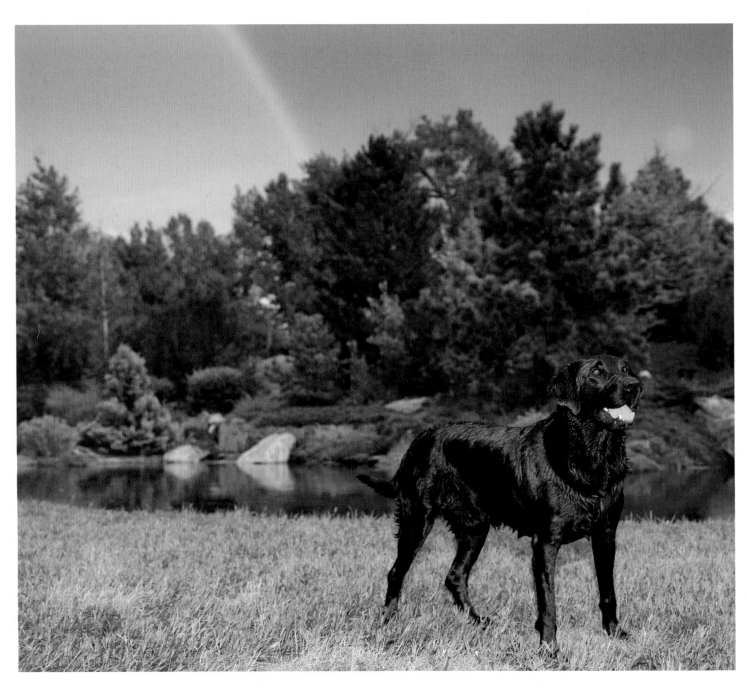

BRANDEE • Labrador Retriever • Boulder, CO

RUMOR • Vizsla • Sonoita, AZ (opposite)

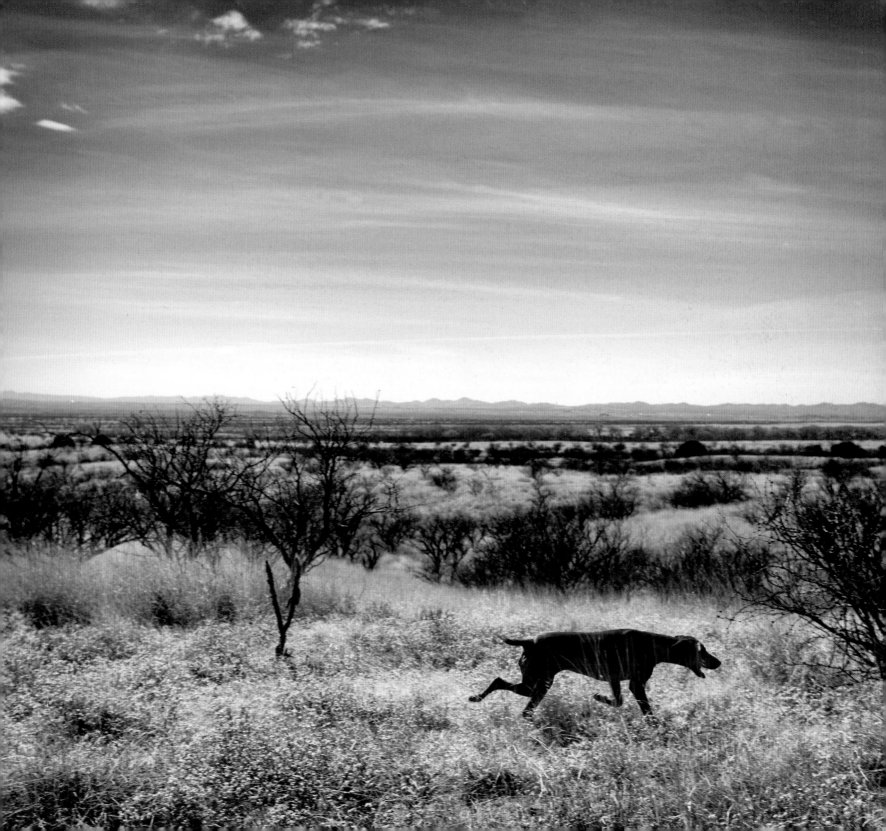

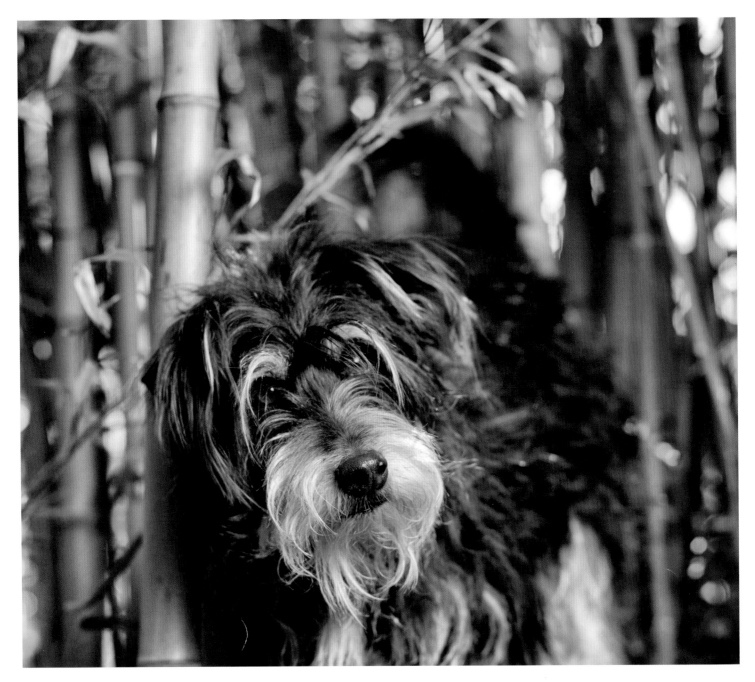

MR. FINLEY • *Mixed Breed* • Berkeley, CA

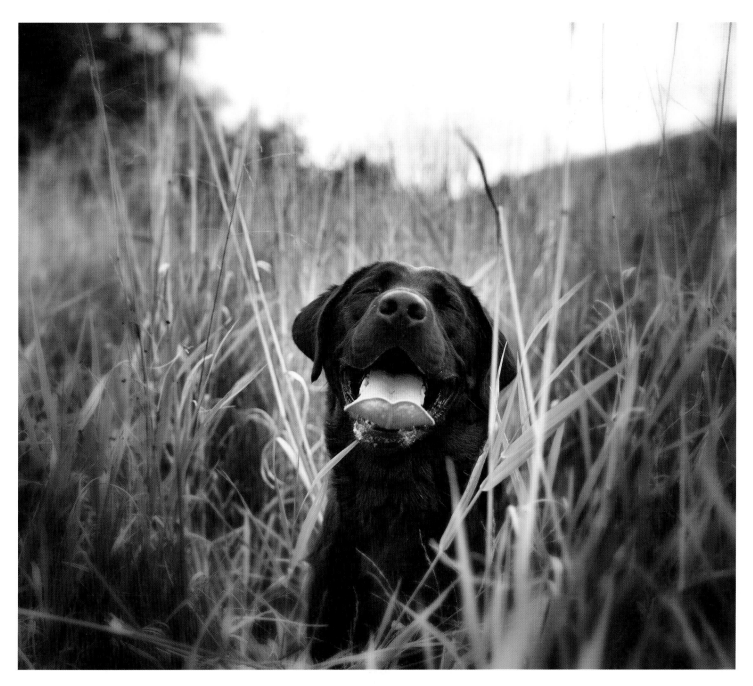

OSCAR • Labrador Retriever • Williamstown, MA

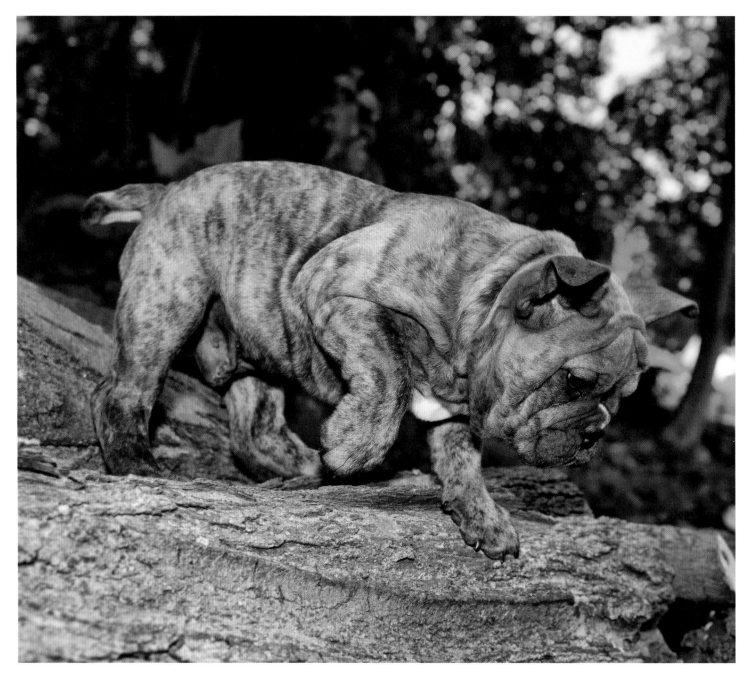

CLIVE • *Bulldog* • North Adams, MA

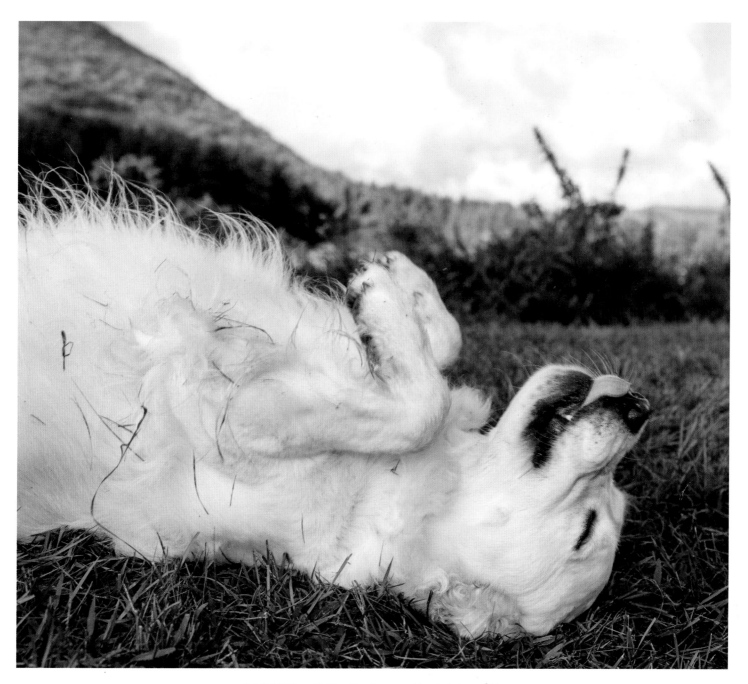

CARSEN • Golden Retriever • North Adams, MA

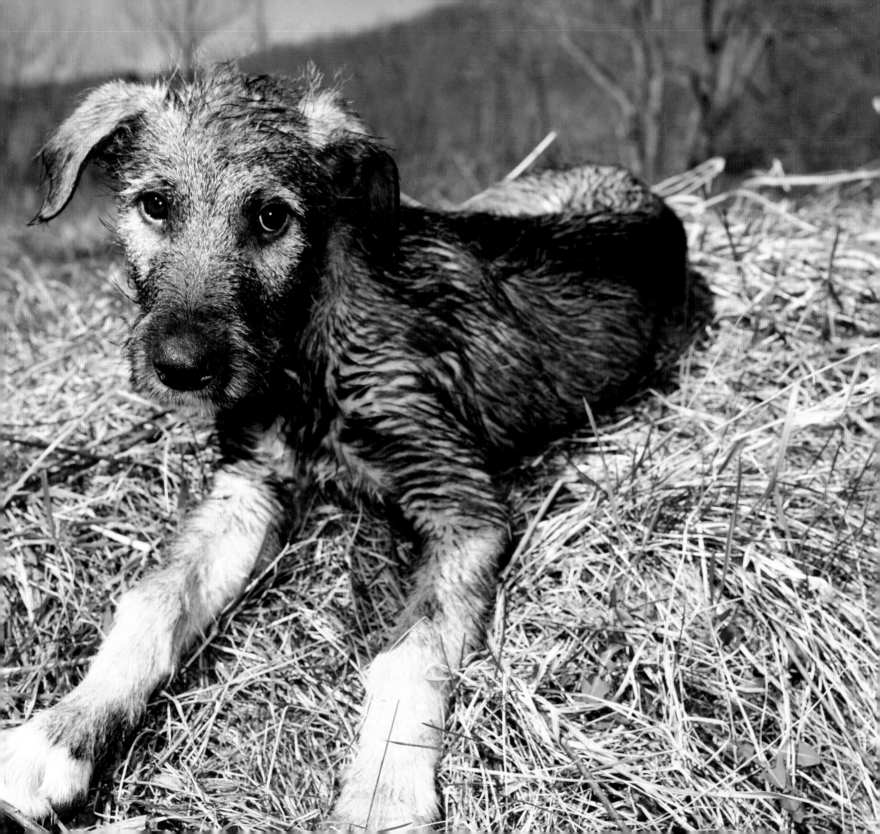

BUDDY • Mixed Breed • Adams, MA

JAMESON • Irish Wolfhound • Vestal, NY (opposite)

MYLLO • Yorkshire Terrier • Williamstown, MA

LULU • **Pit Bull** • San Francisco, CA

FAXON • German Shepherd • Dallas, TX

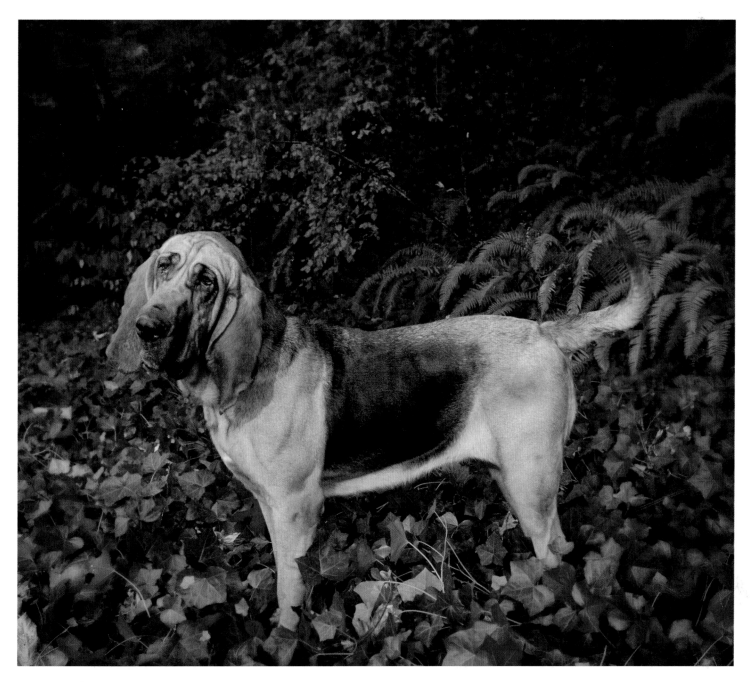

CLARA • Bloodhound • Portland, OR

SUMMER

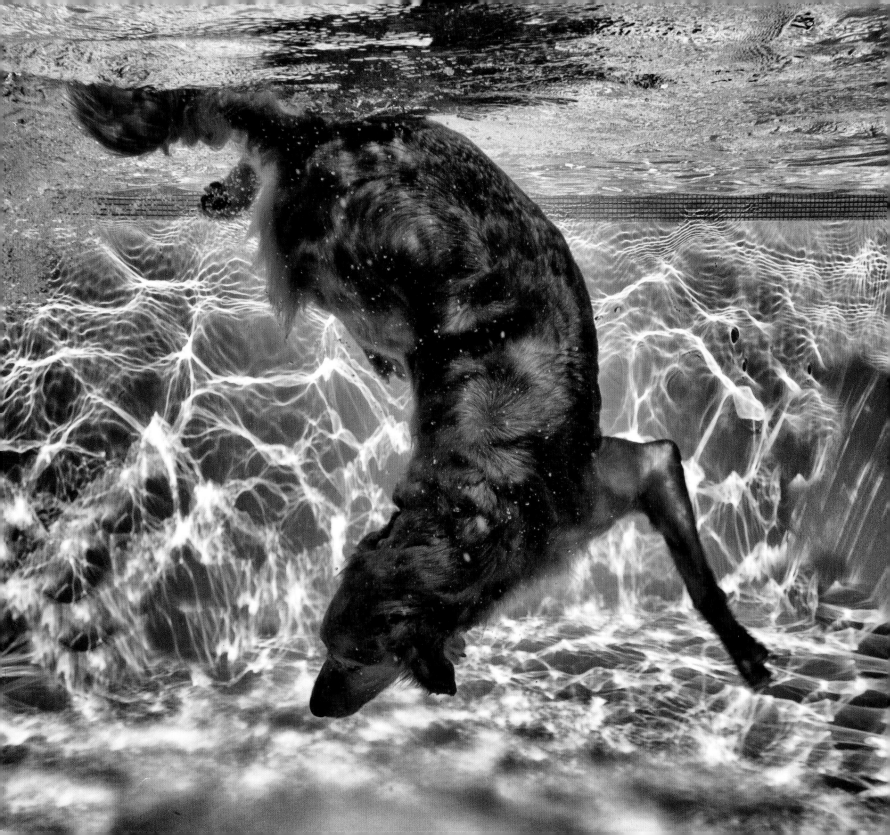

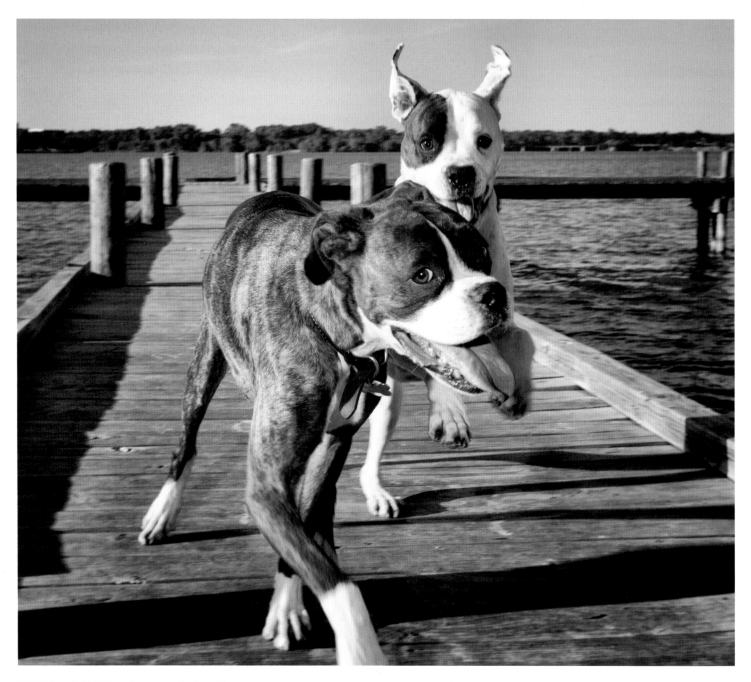

STELLA & ZOE • Boxers • Dallas, TX

ISAAC • Golden Retriever • Fort Worth, TX (previous)

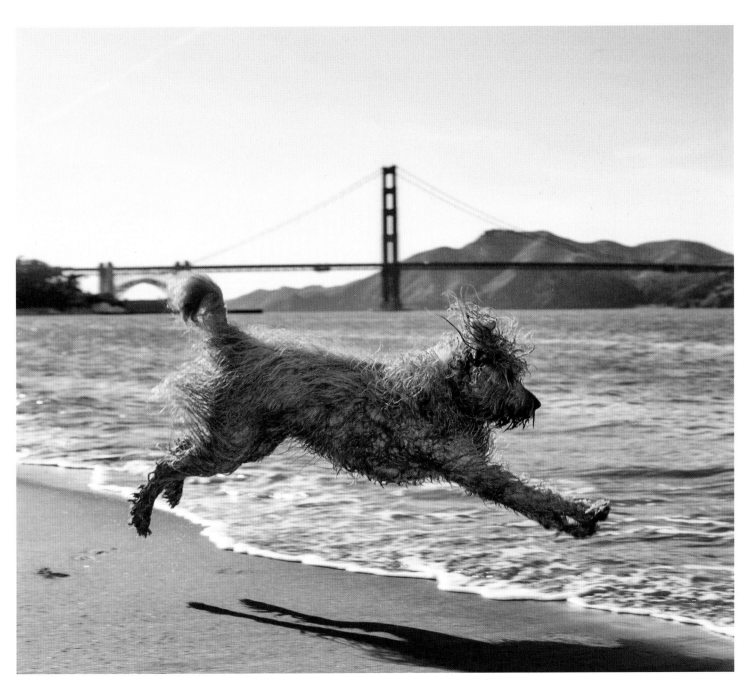

SHILOH • Labradoodle • San Francisco, CA

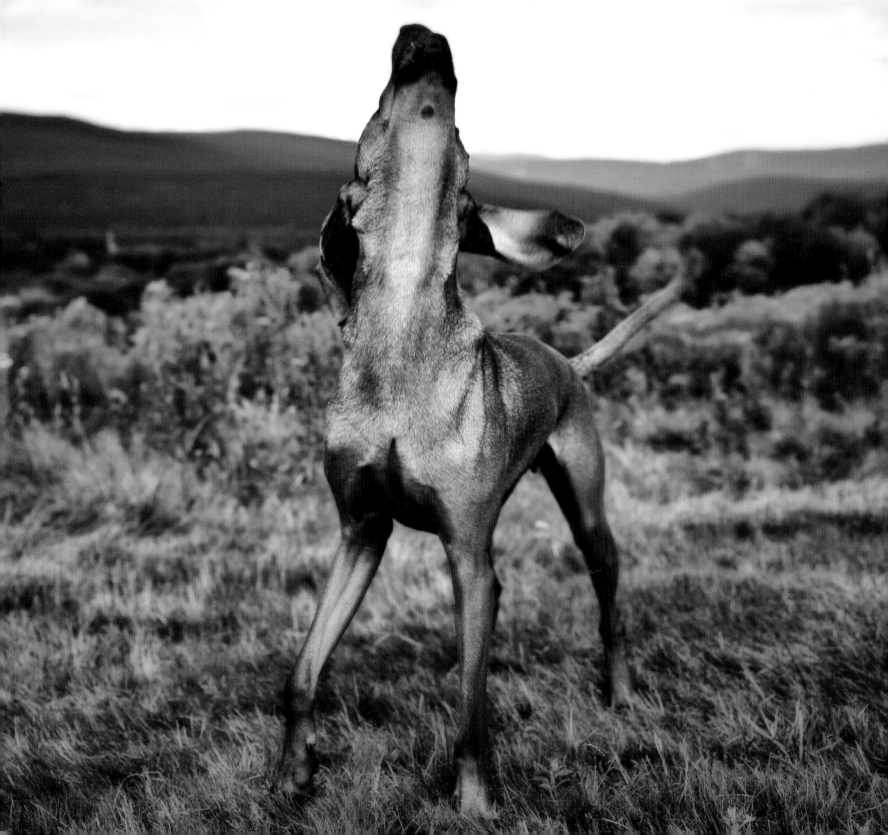

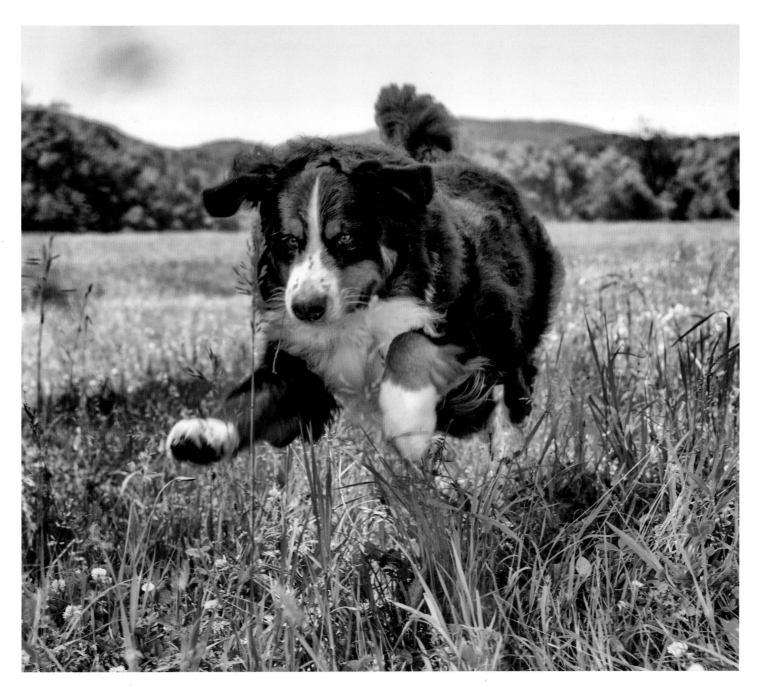

CHURCHILL • Bernese Mountain Dog • Williamstown, MA

MILES • Redbone Coonhound • Williamstown, MA (opposite)

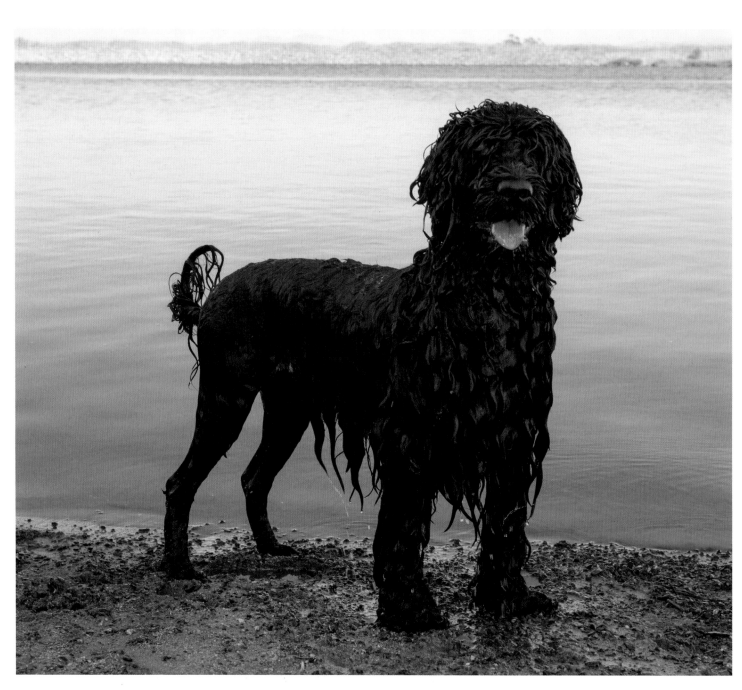

KEEVA • Portuguese Water Dog • Bel Marin Keys, CA

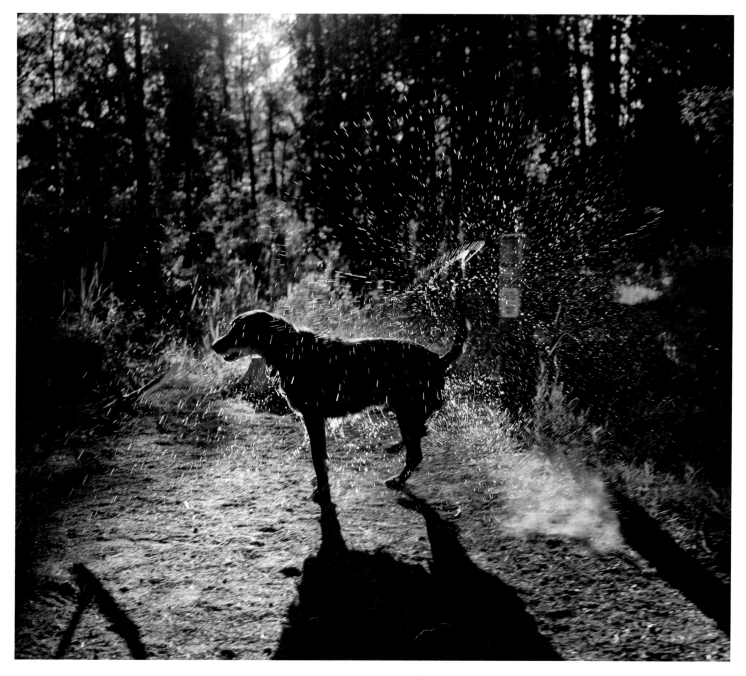

CHARLIE • Labrador Retriever • Bend, OR

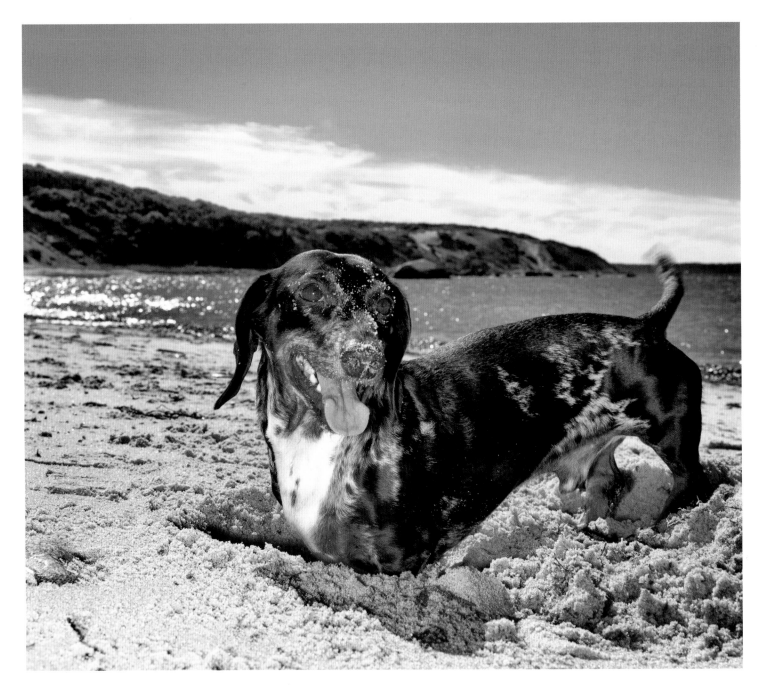

BENNY • *Dachshund* • Martha's Vineyard, MA

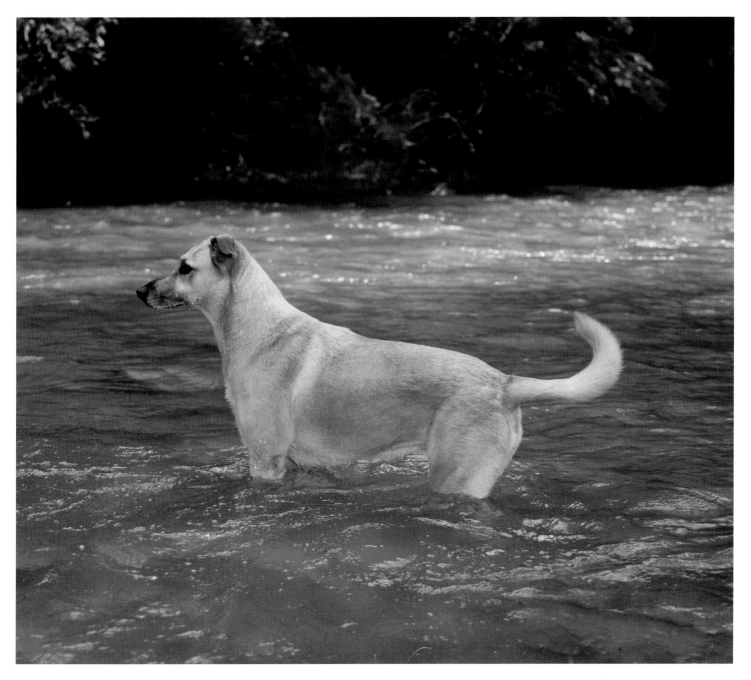

ANYA • Mixed Breed • Williamstown, MA

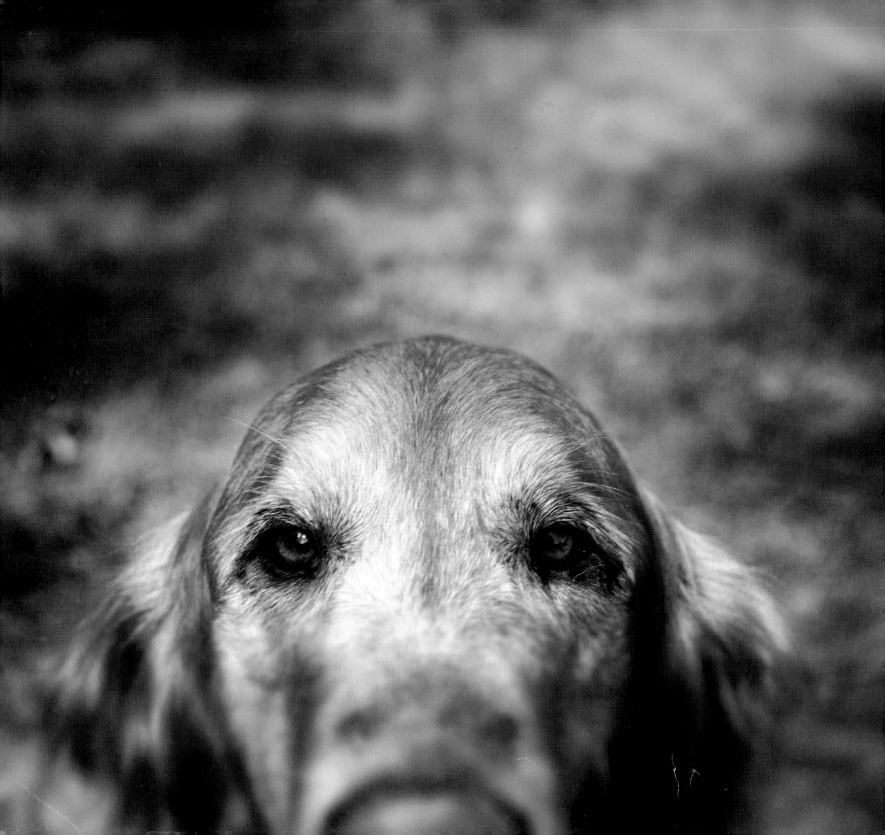

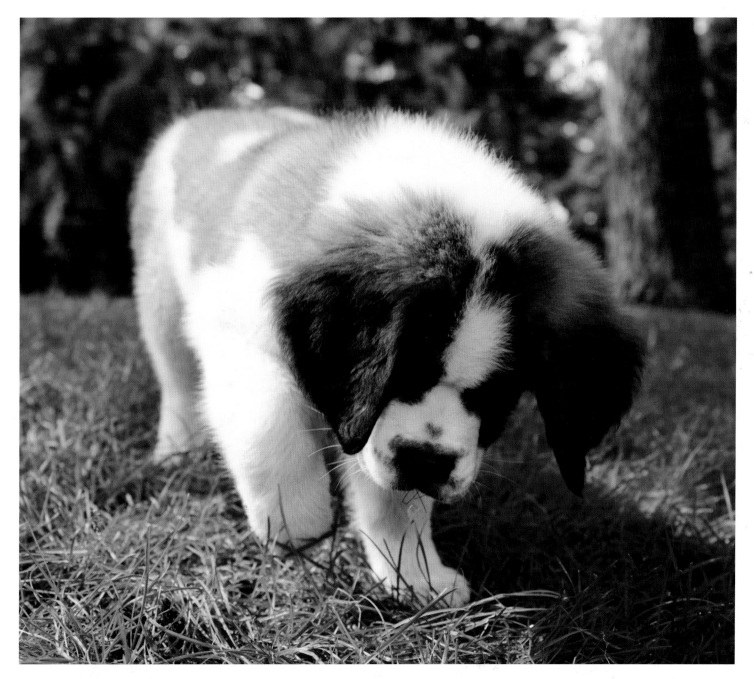

BARREL • St. Bernard Puppy • Bend, OR

COMET • Golden Retriever • Black Earth, WI (opposite)

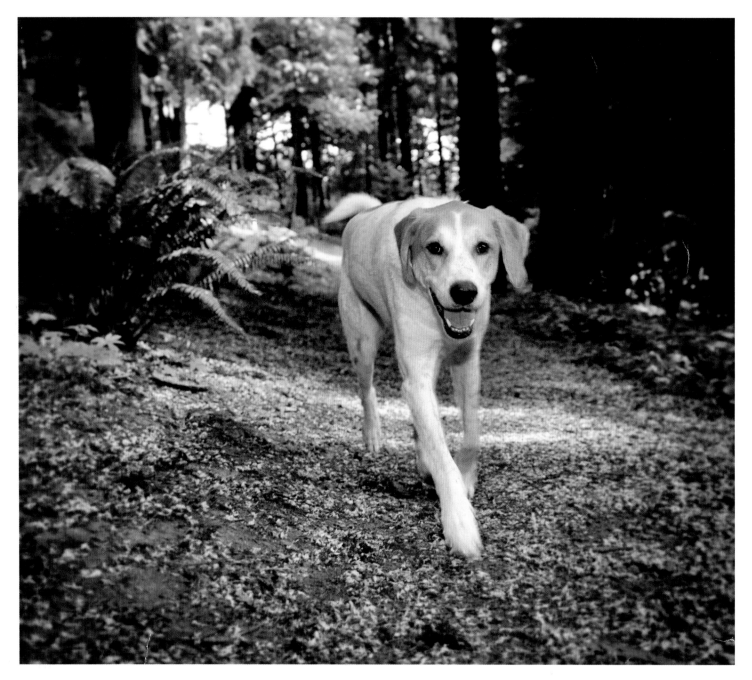

KONA • Mixed Breed • Portland, OR

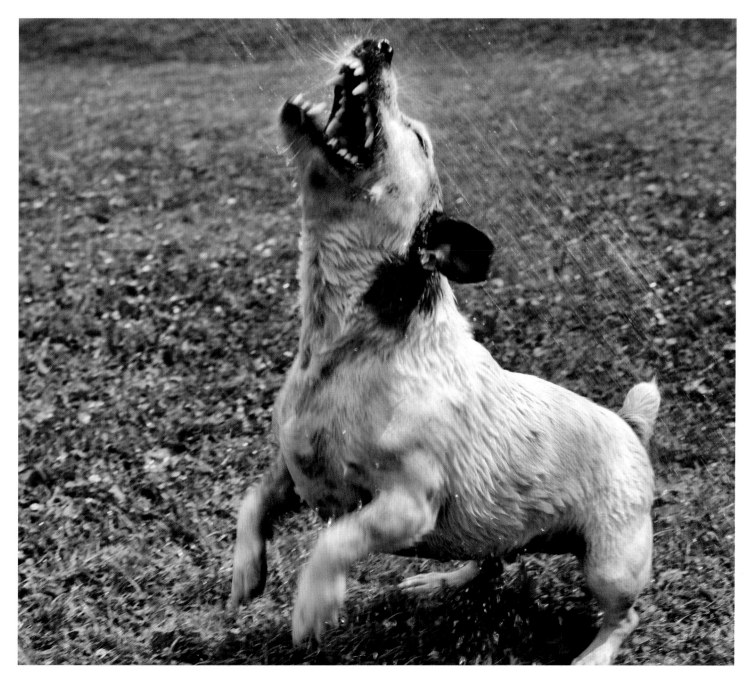

JACK • Jack Russell Terrier • North Adams, MA

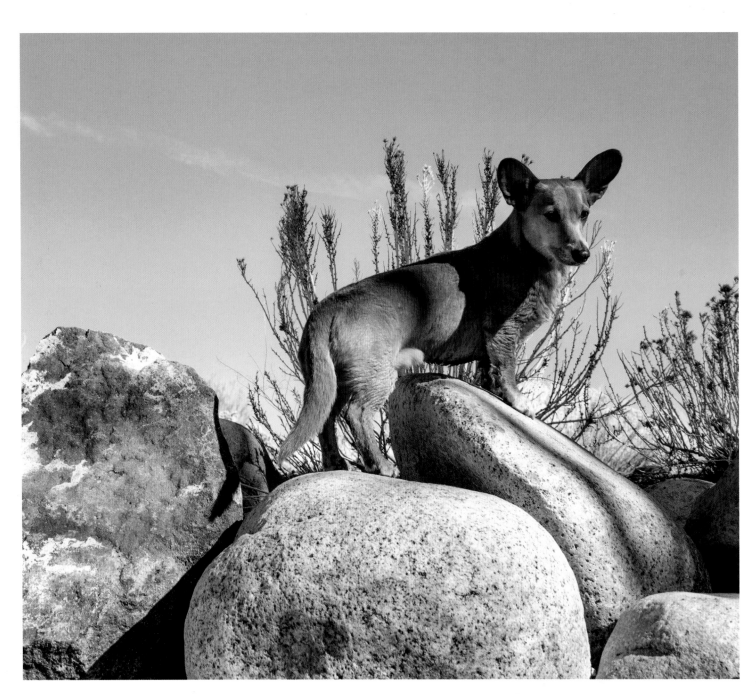

CHEWY • Mixed Breed • Reno, NV

MINNIE • Airedale Terrier • Napa, CA (opposite)

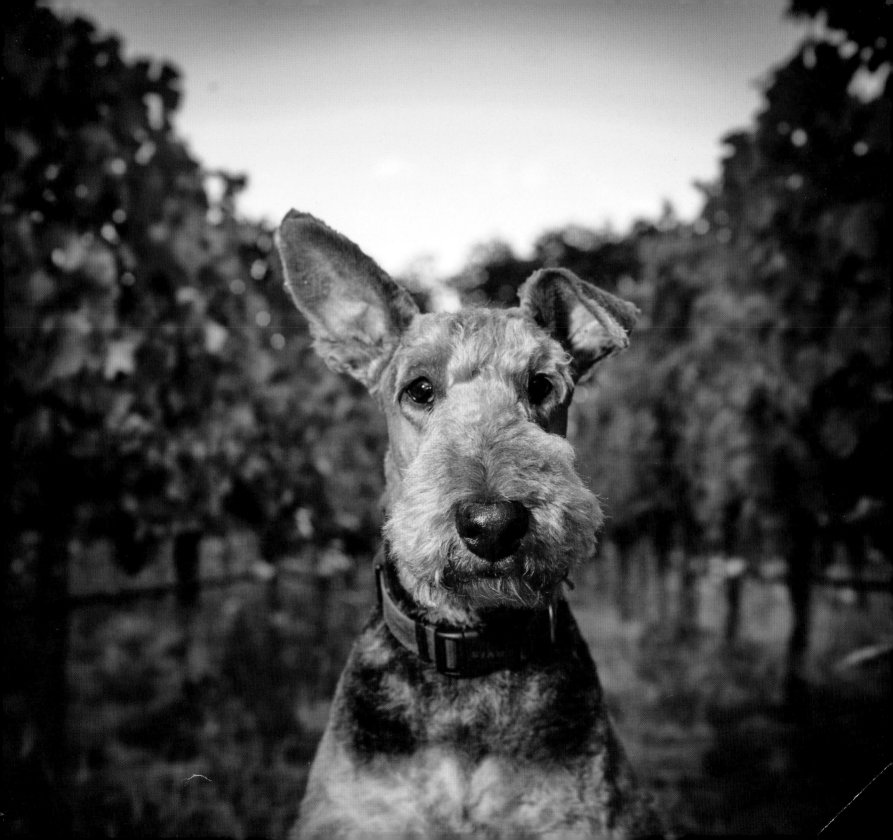

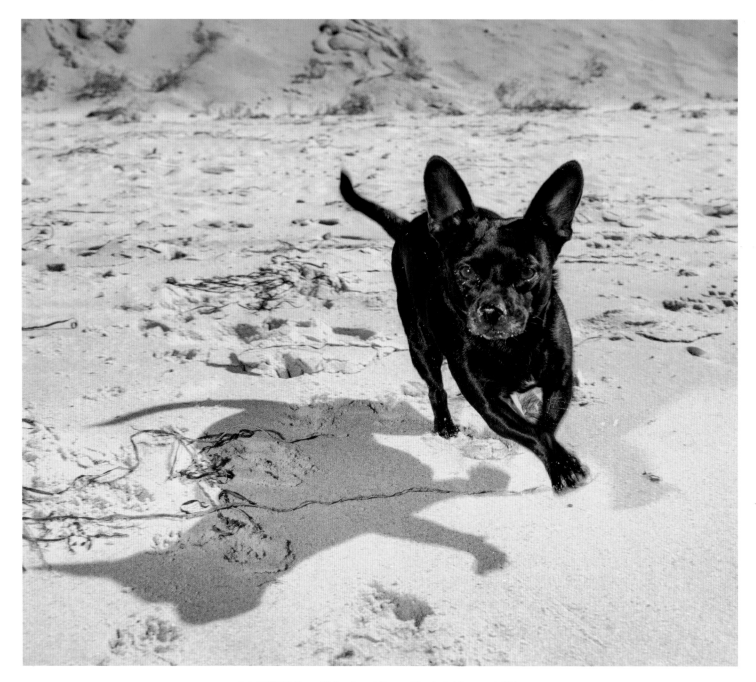

LADYBUG • Chihuahua Mix • Martha's Vineyard, MA

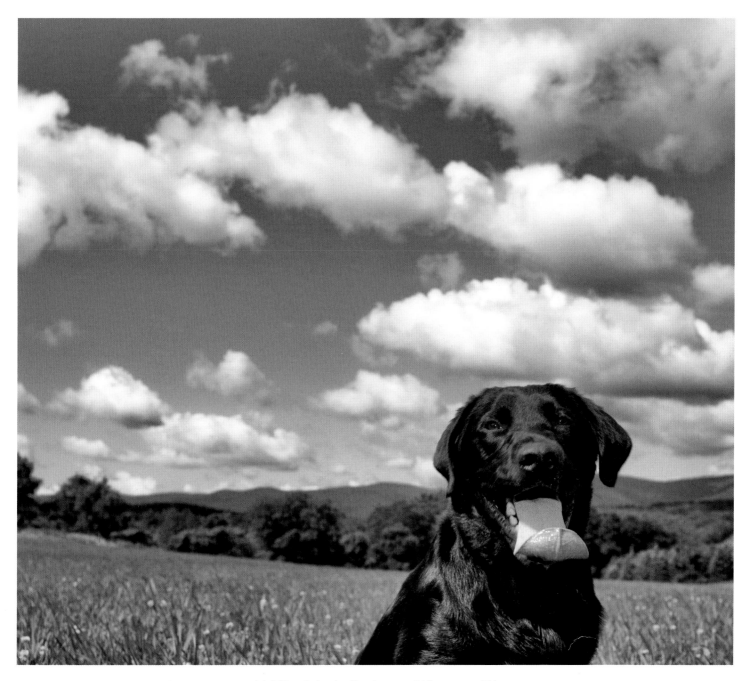

JACK • Labrador Retriever • Williamstown, MA

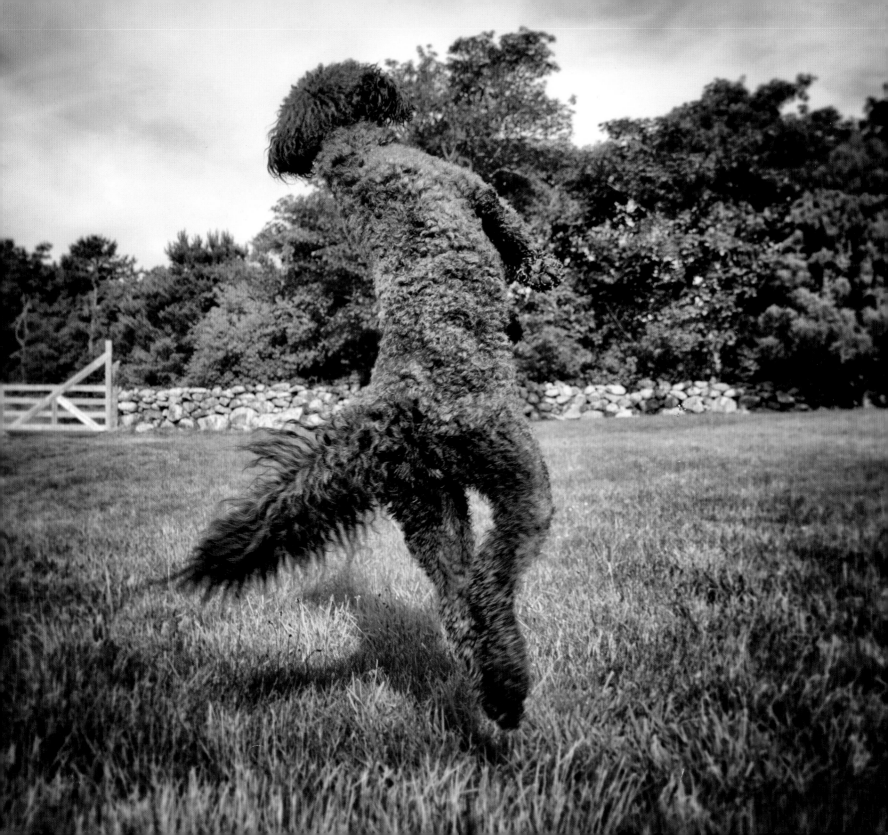

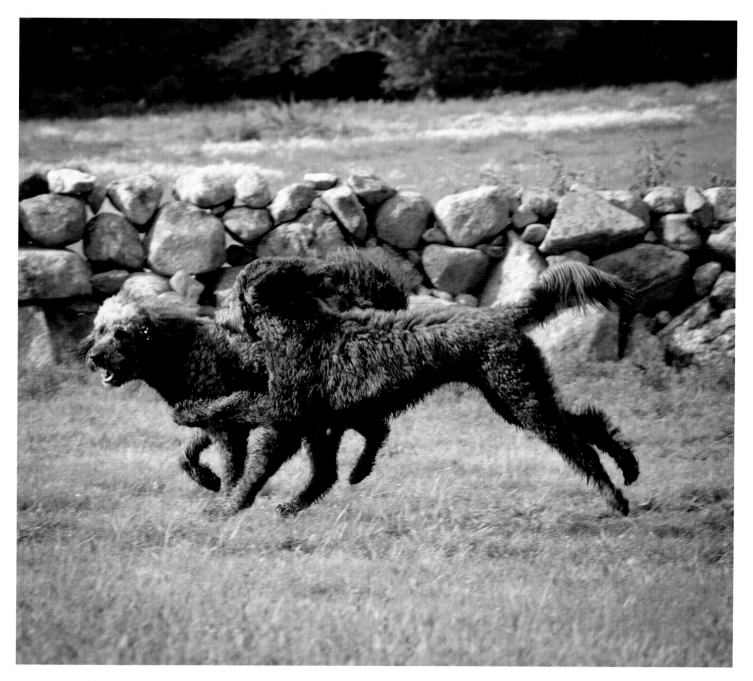

CLARKE & CRICKET • Labradoodles • Martha's Vineyard, MA

CLARKE • Labradoodle • Martha's Vineyard, MA (opposite)

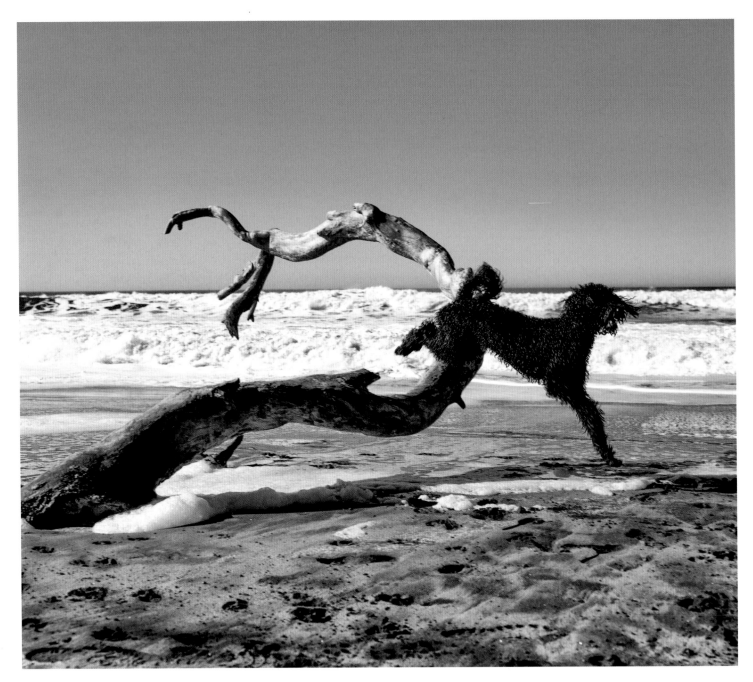

LULU • **Labradoodle** • San Francisco, CA

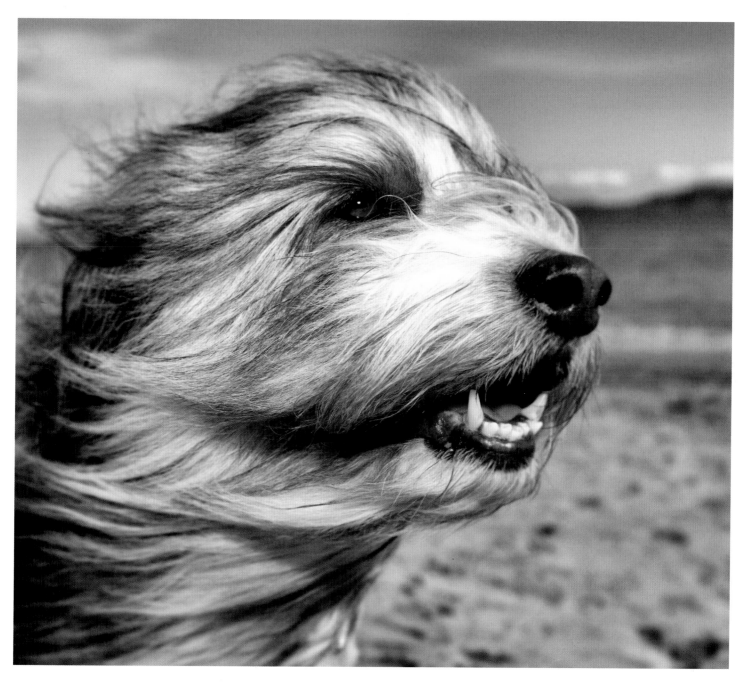

TRUMAN • Bearded Collie • San Francisco, CA

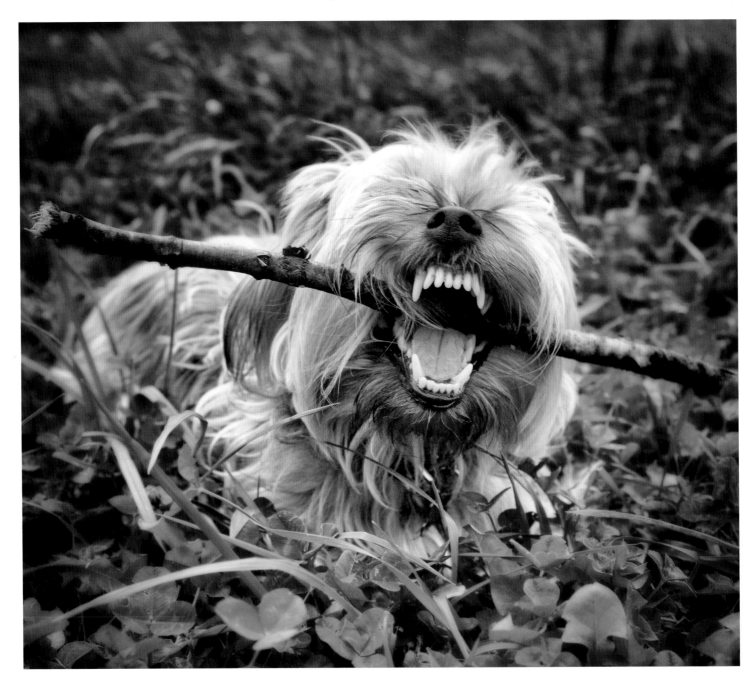

MYLLO • Yorkshire Terrier • Williamstown, MA

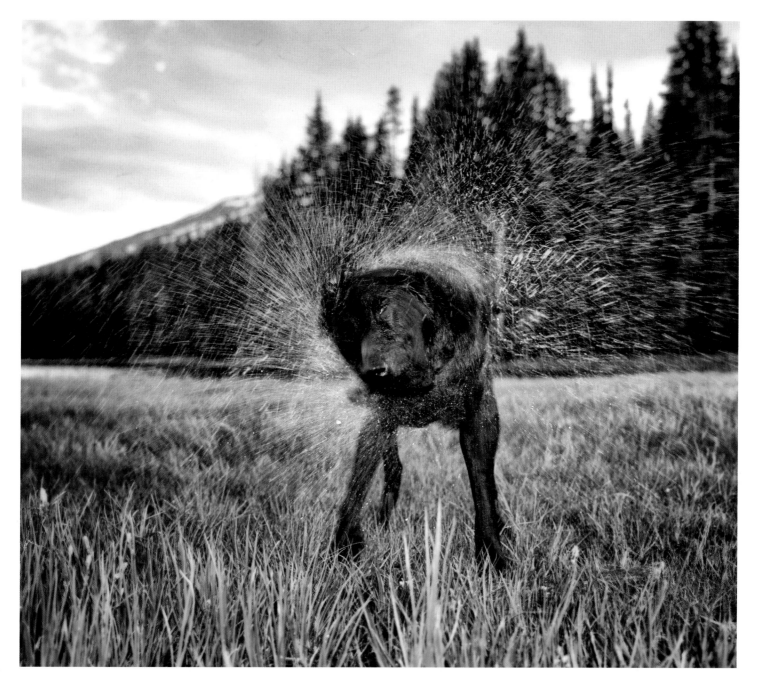

LAKER • Labrador Retriever • Bend, OR

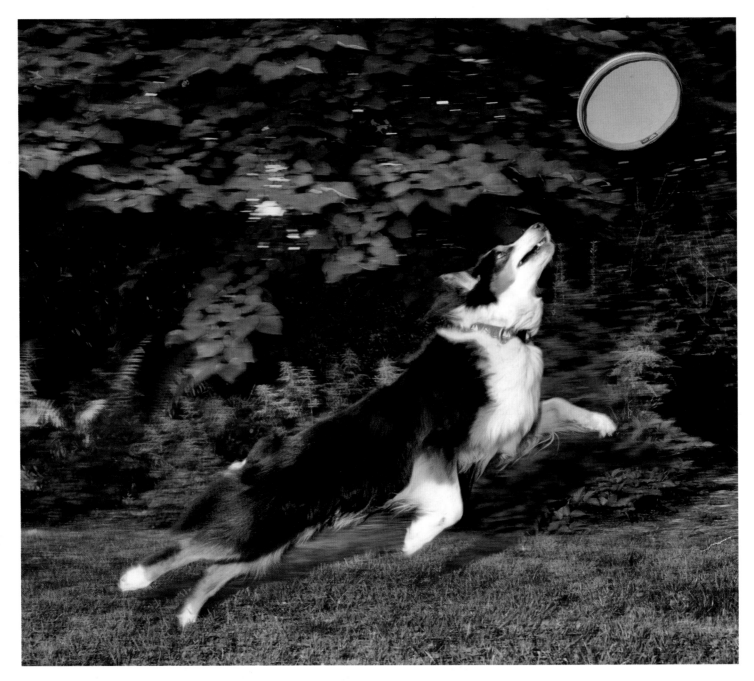

SHEP • Australian Shepherd • McLean, VA

HULA • Labrador Retriever • Half Moon Bay, CA (opposite)

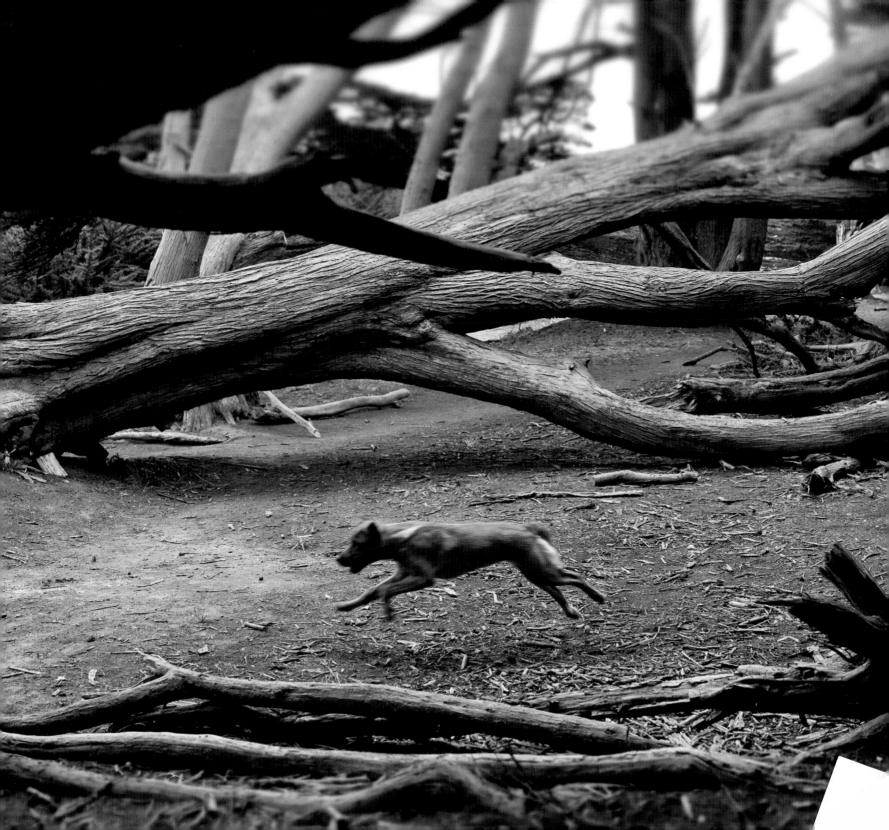

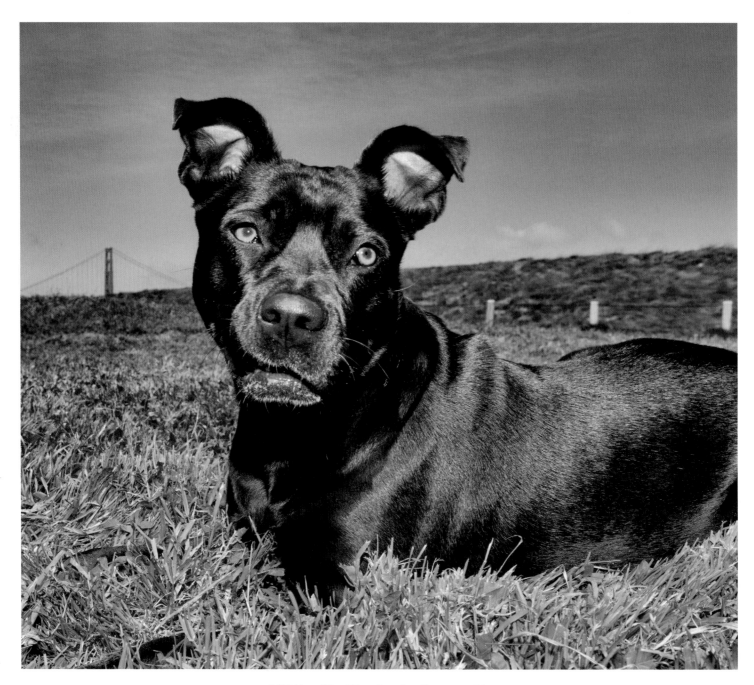

LULU • *Mixed Breed* • San Francisco, CA

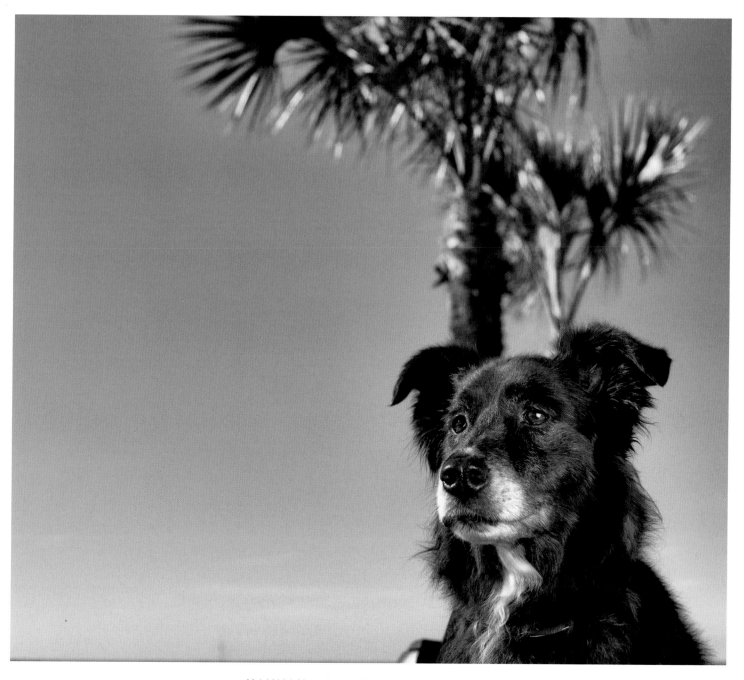

HANNAH • Border Collie Mix • Galveston, TX

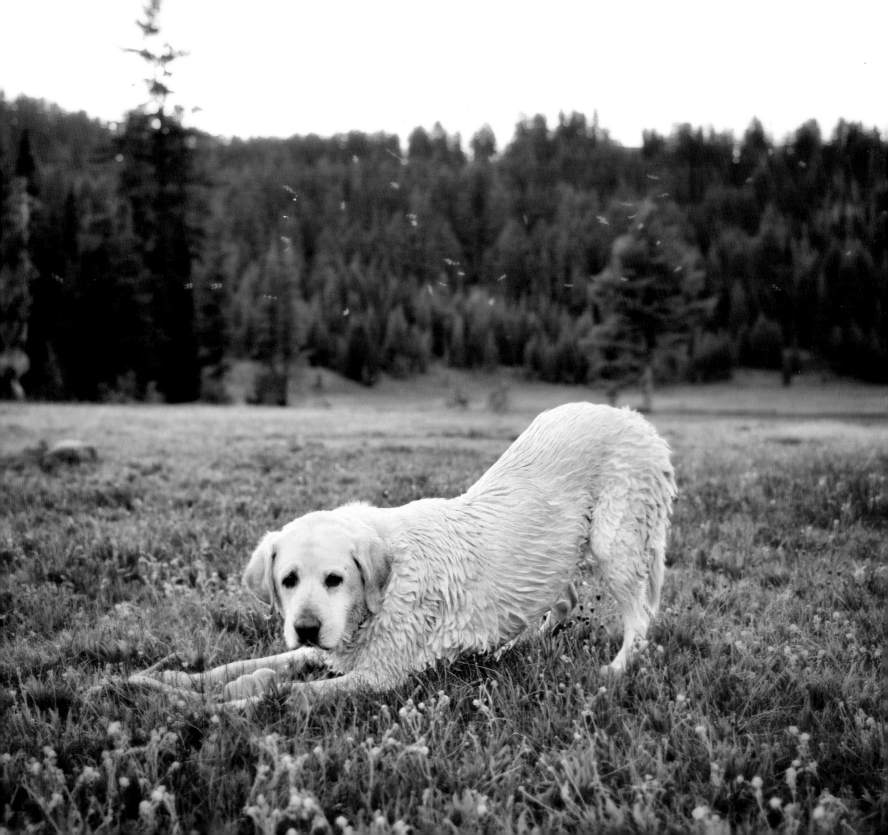

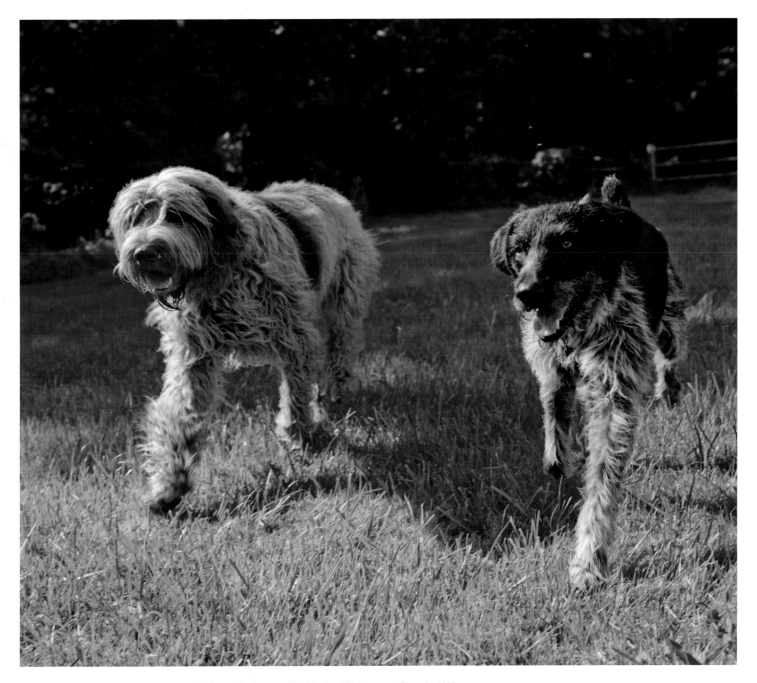

VINNIE & JAEGER • Spinone Italiano & German Wirehaired Pointer • Seattle, WA

NOAH • Labrador Retriever • Bend, OR (opposite)

FALL

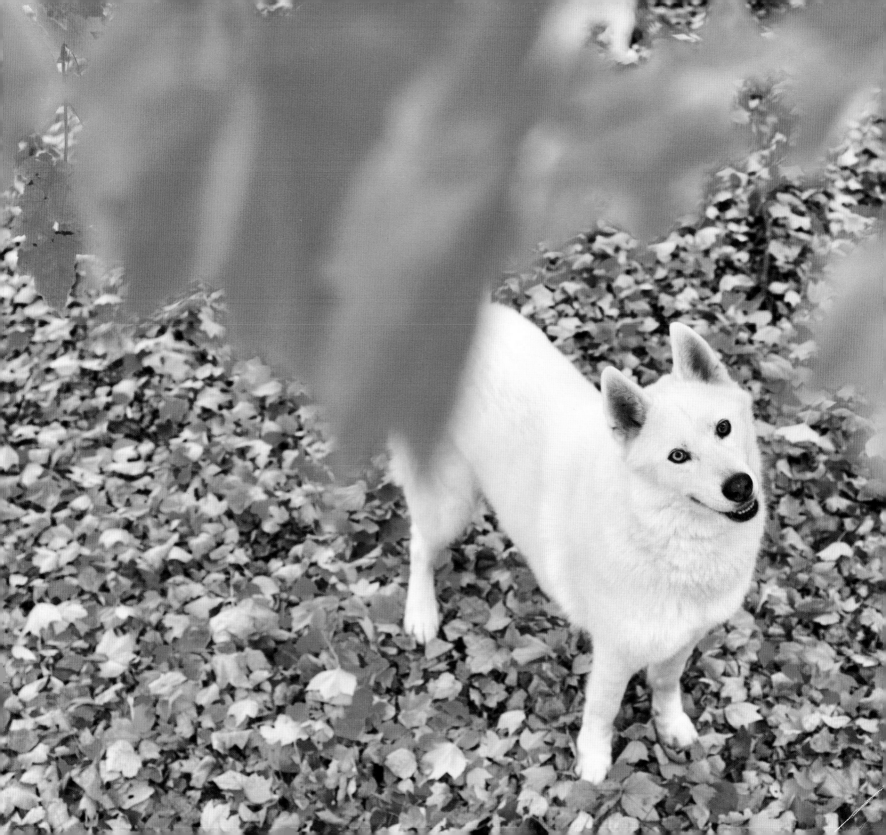

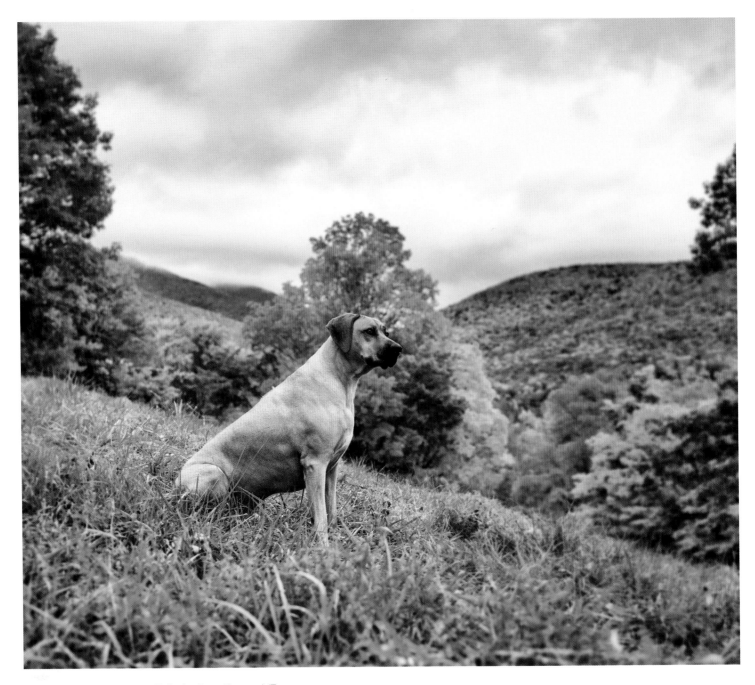

MORGAN • Rhodesian Ridgeback • Dorset, VT

KONA • Siberian Husky • North Adams, MA (previous)

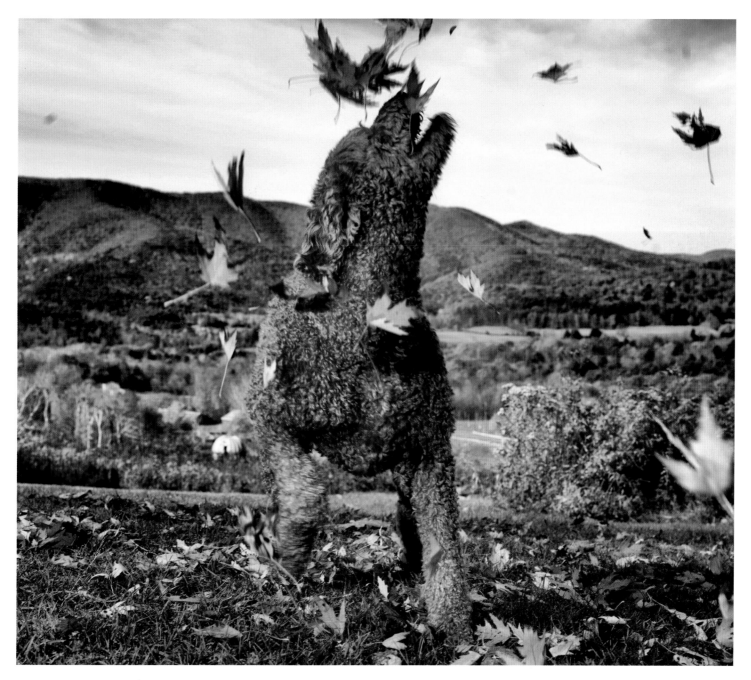

RUBY • **Poodle** • Pownal, VT

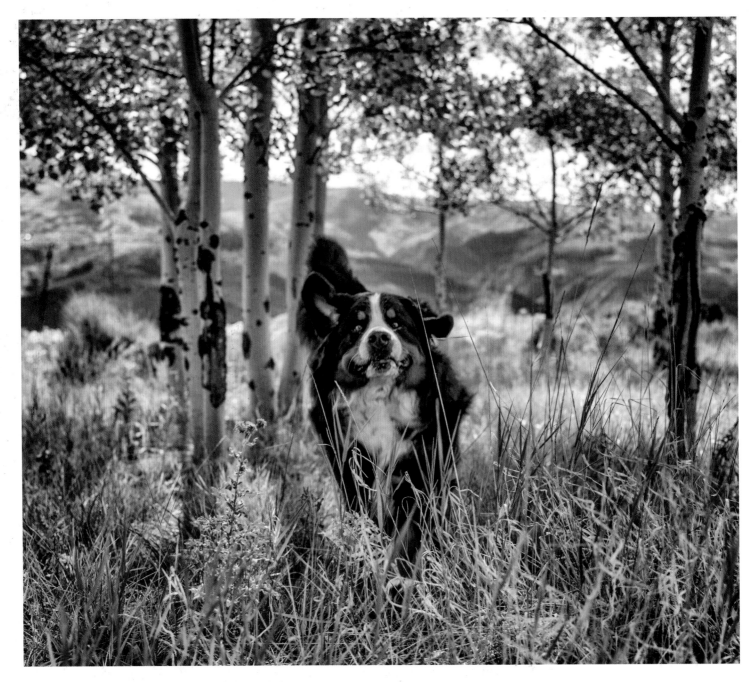

JJ • Bernese Mountain Dog • Beaver Creek, CO

GINGER & SMUDGE • Golden Retriever & Great Pyrenees Mix • Hoosick Falls, NY (opposite)

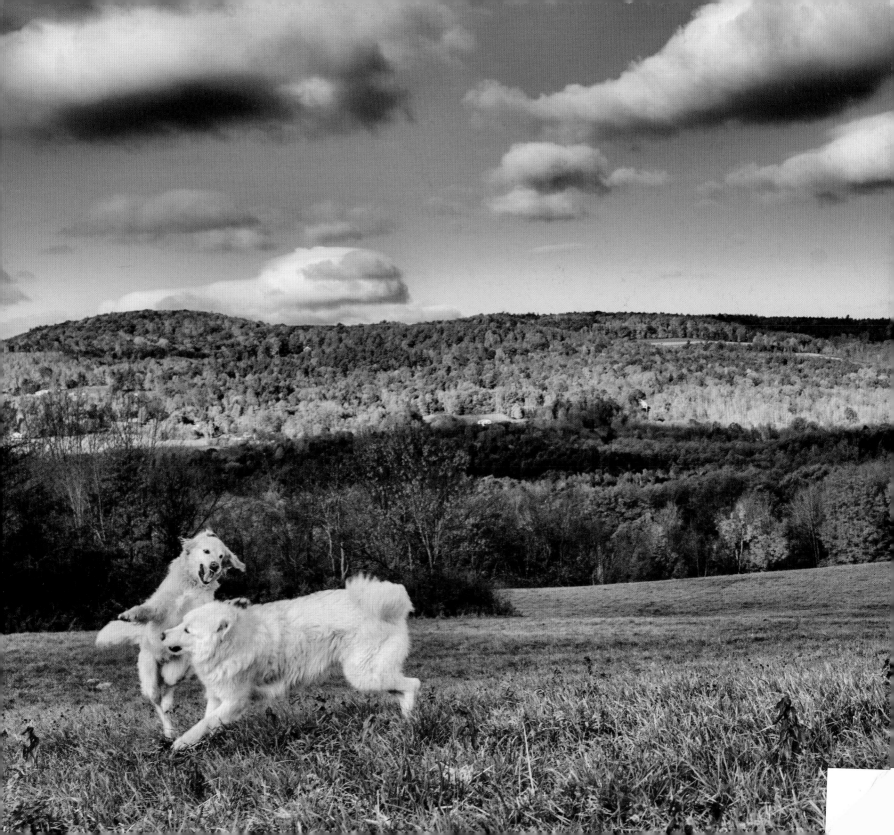

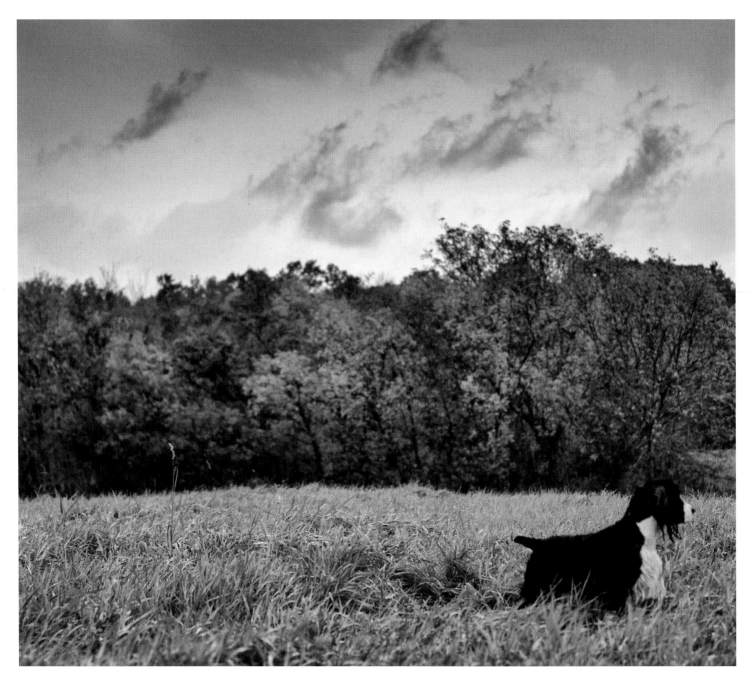

LOGAN • English Springer Spaniel • Williamstown, MA

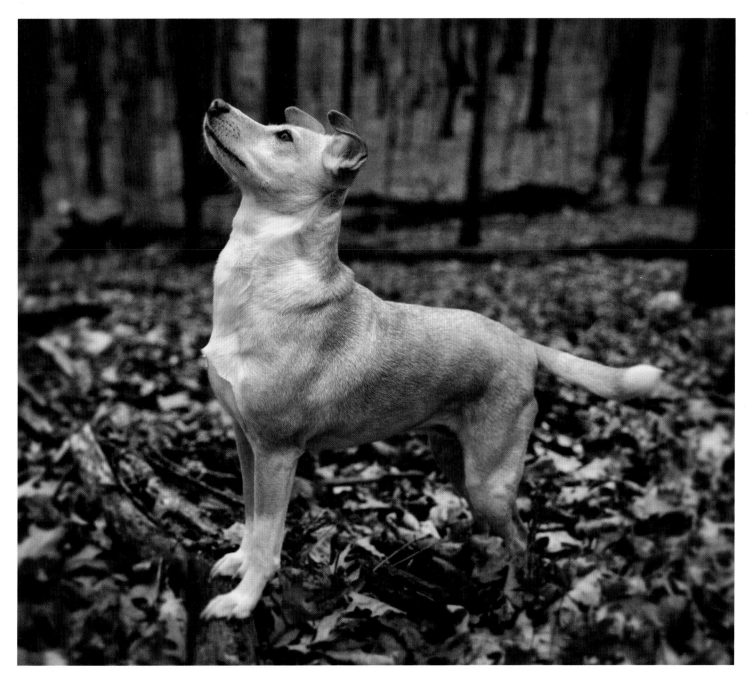

FOXXY • **Mixed Breed** • Broad Run, VA

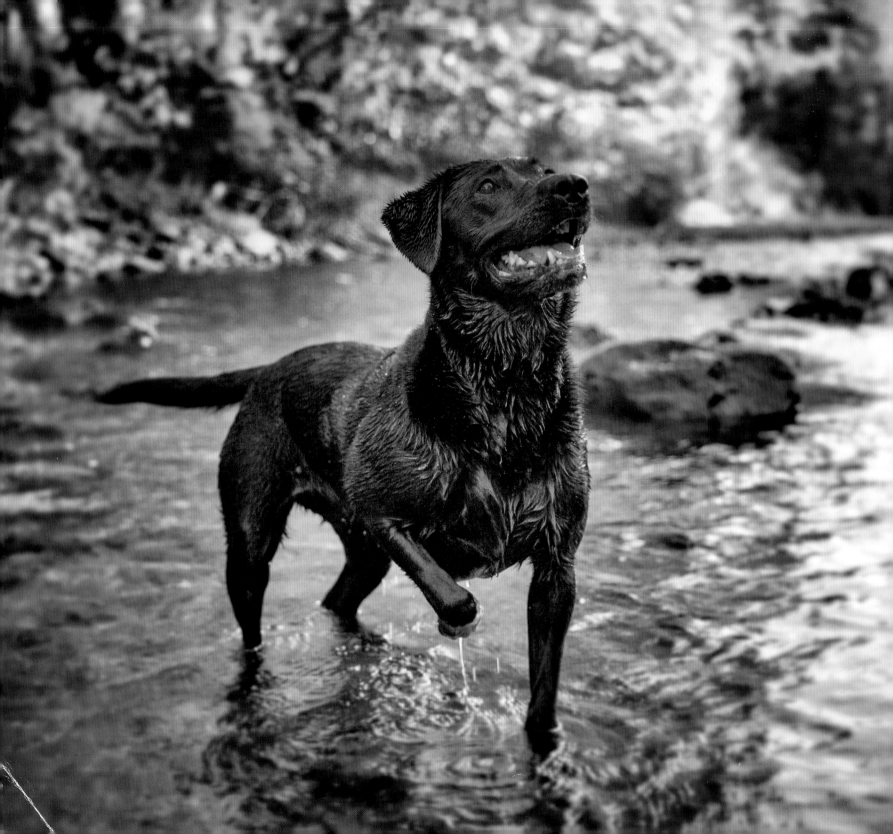

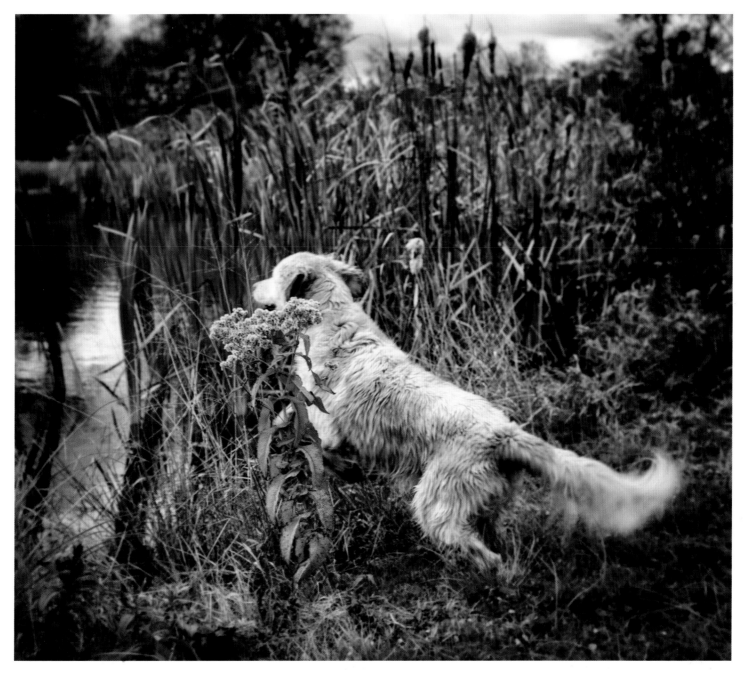

GINGER • Golden Retriever • Hoosick Falls, NY

LUCY • Labrador Retriever • Williamstown, MA (opposite)

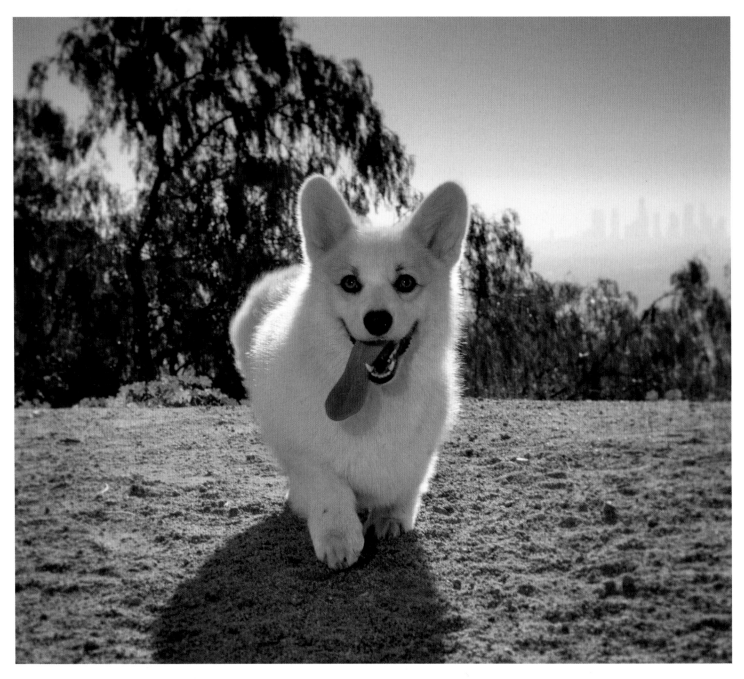

WINSTON • *Corgi* • Los Angeles, CA

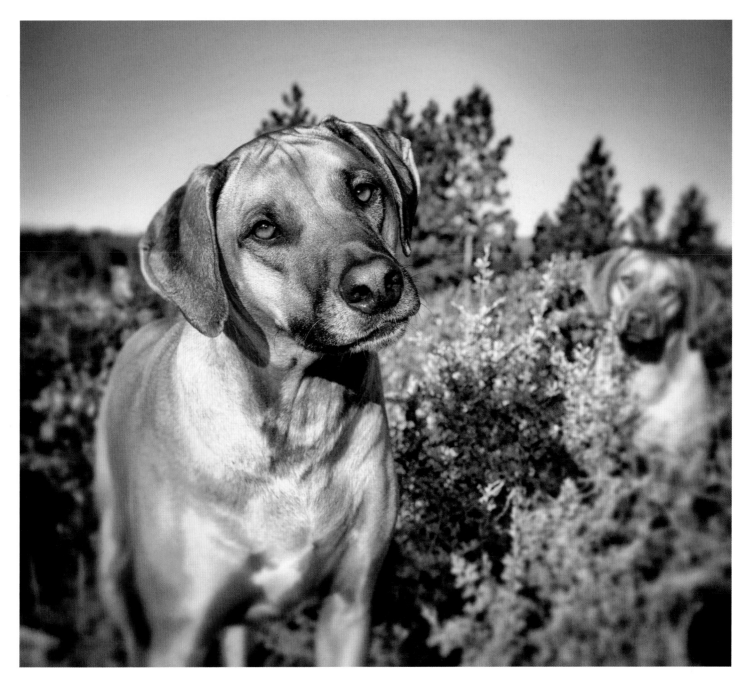

TUNJI & DADA • Rhodesian Ridgebacks • Bend, OR

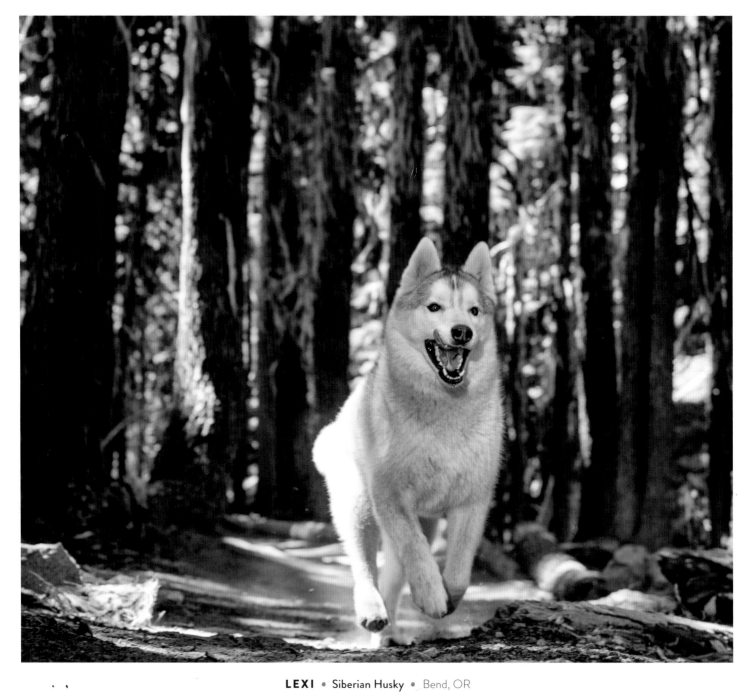

LEXI • Siberian Husky • Bend, OR

GRACE • Mixed Breed • Williamstown, MA

BENNY & LADYBUG • Dachshund & Chihuahua Mix • Martha's Vineyard, MA

LOLA • Poodle • Windmere, FL (opposite)

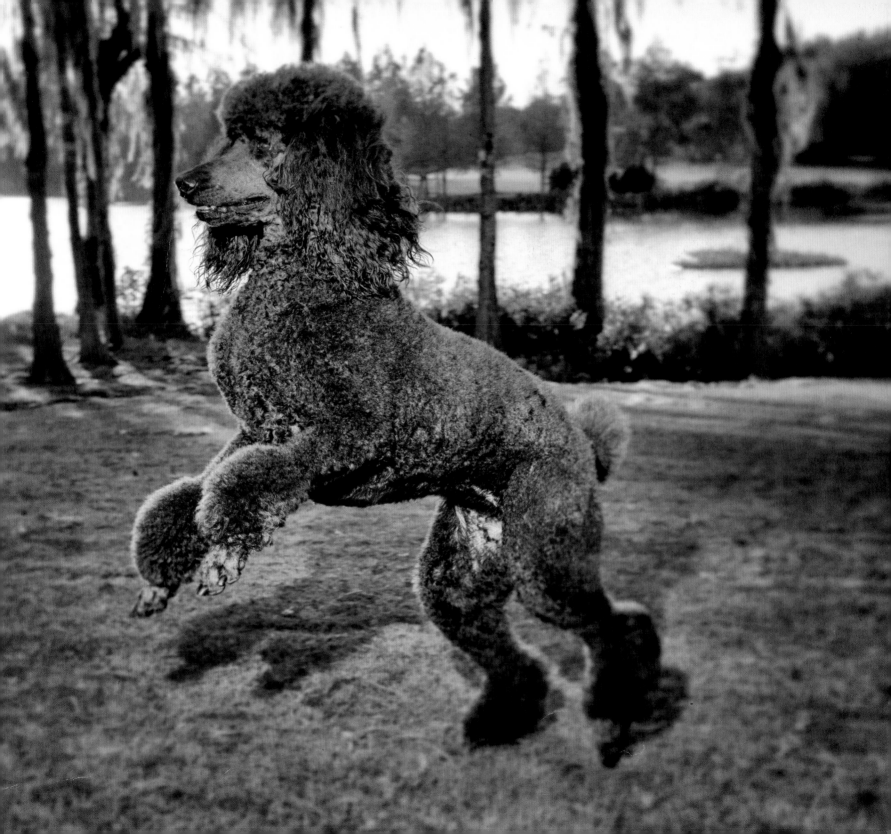

HULA • Labrador Retriever • Half Moon Bay, CA

MAX • Cairn Terrier • Stamford, VT

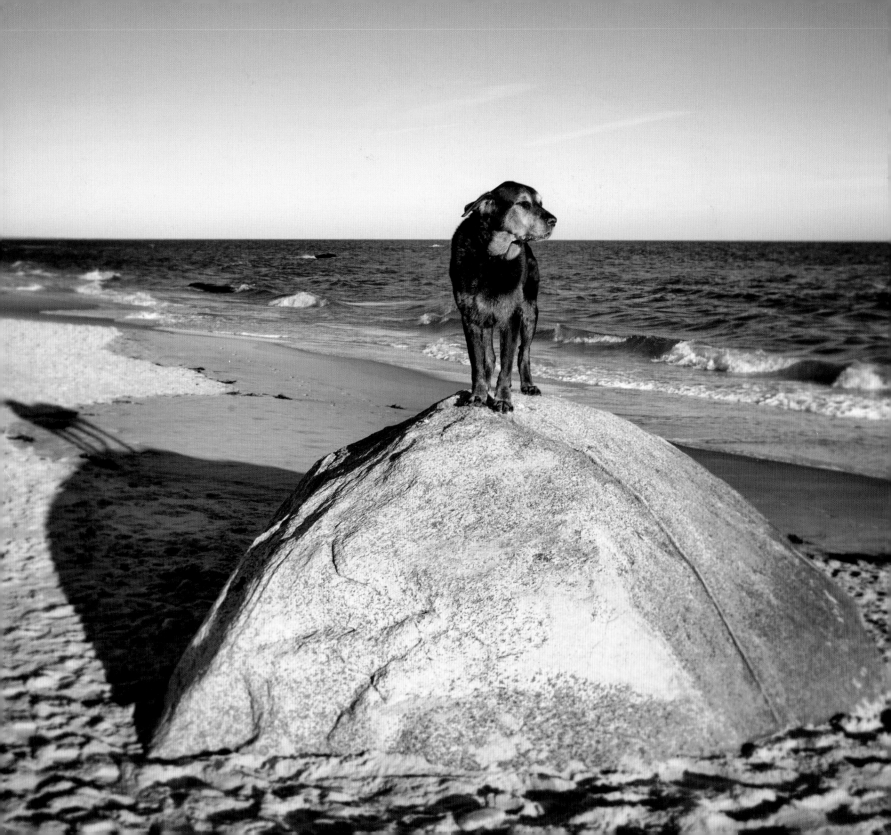

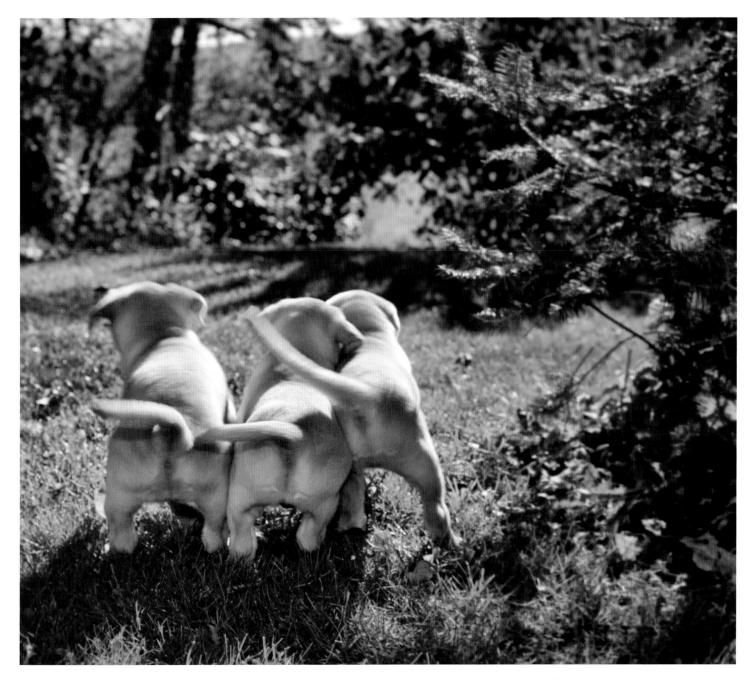

HUEY, DEWEY & LOUIE • Labrador Retriever Puppies • Pownal, VT

TINKER • Labrador Retriever Mix • Martha's Vineyard, MA (opposite)

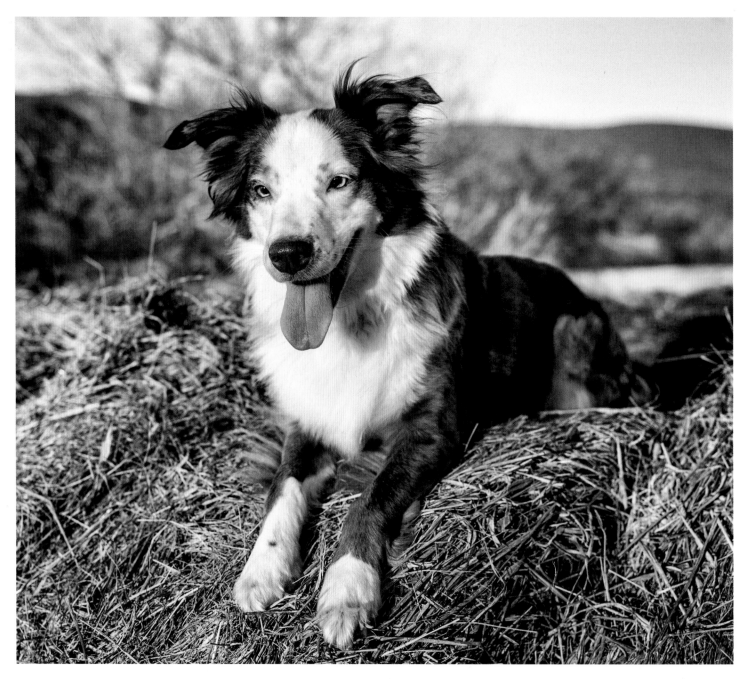

MOLLY • Australian Shepherd • Williamstown, MA

EVE • German Shepherd • Beaver Creek, CO (opposite)

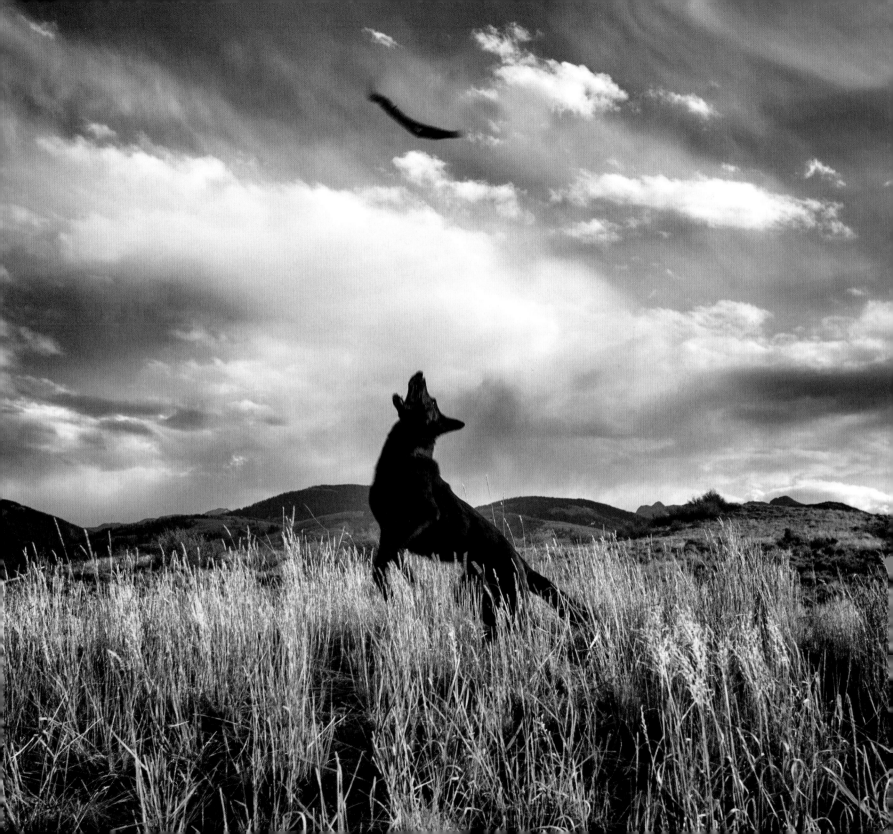

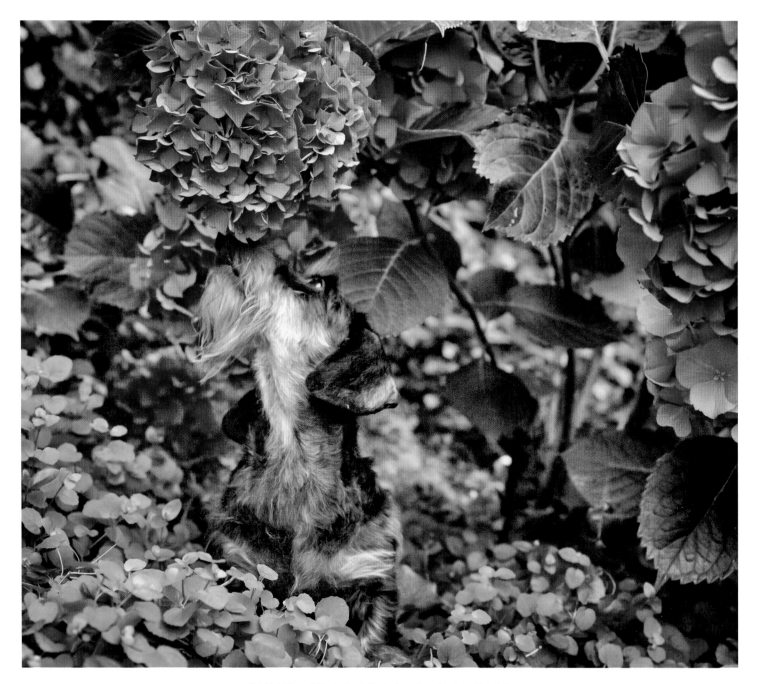

SARAH • Wirehaired Dachshund • Forestville, CA

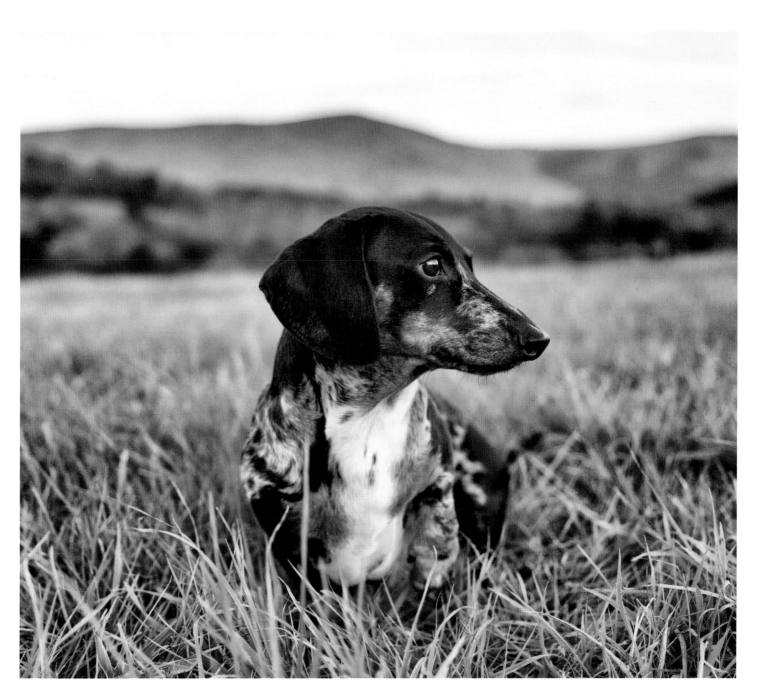

BENNY • Dachshund • Williamstown, MA

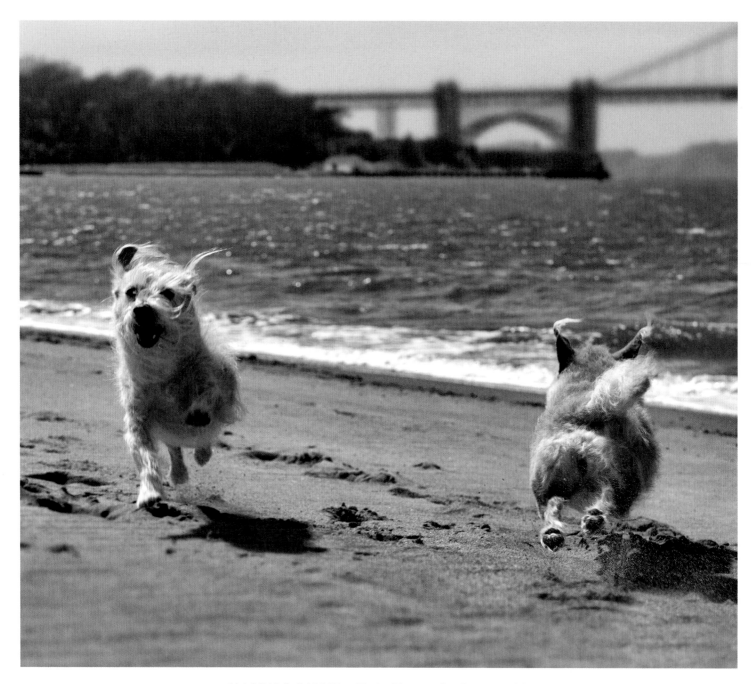

MASON & SALLIE • Terrier Mixes • San Francisco, CA

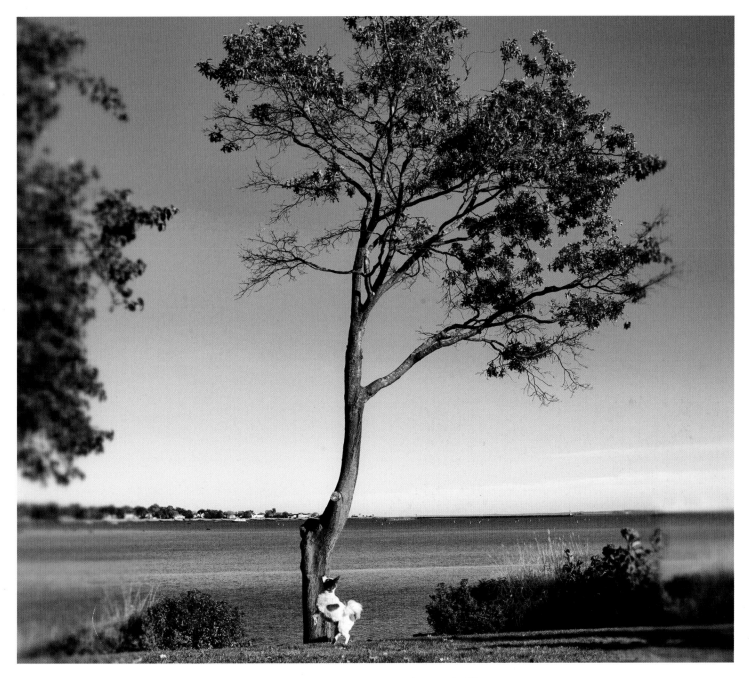

SKIPPER • Papillon • Greenwich, CT

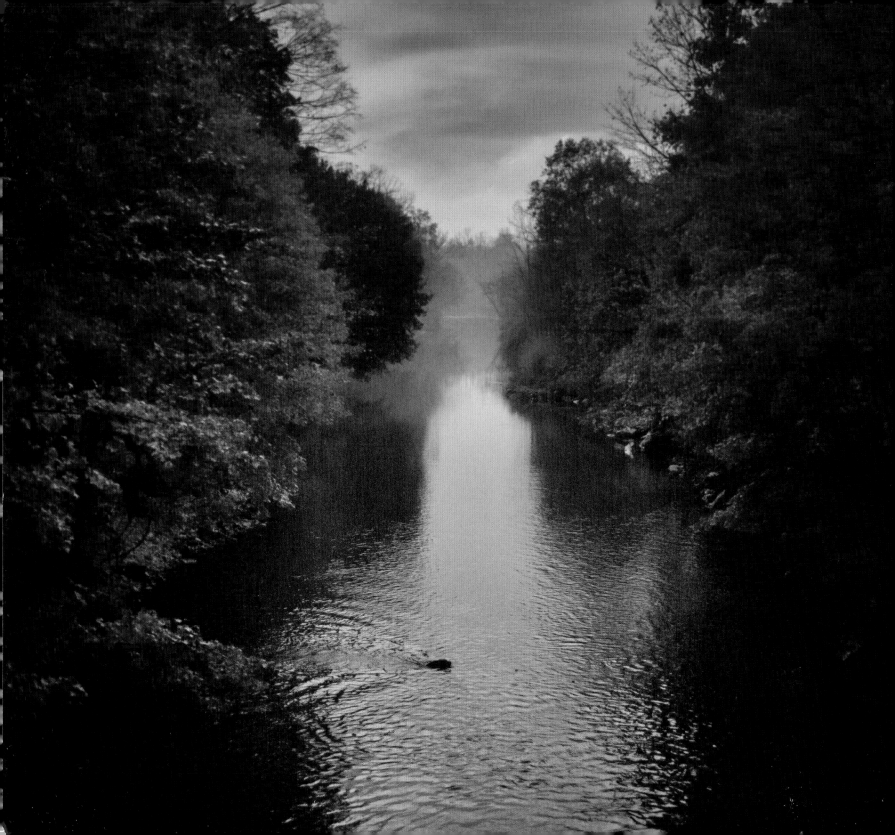

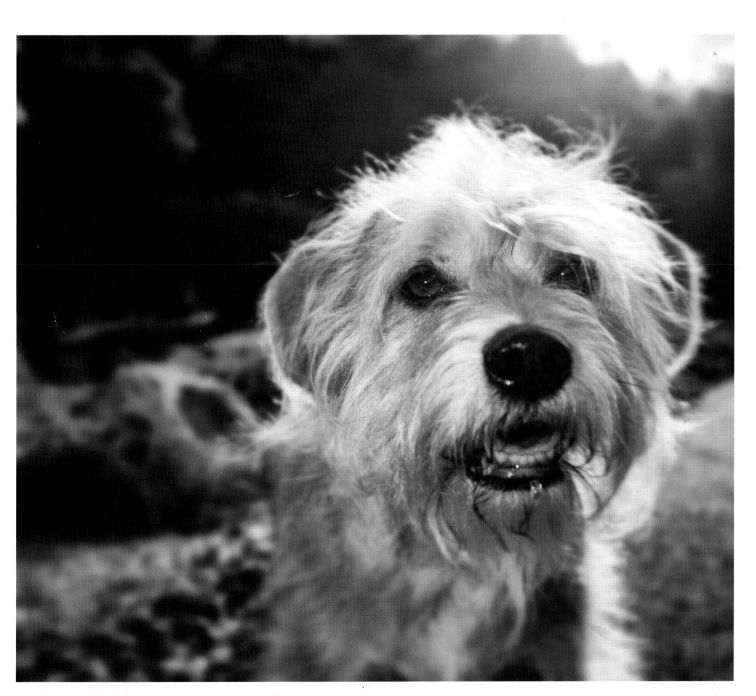

SÉAMUS • Terrier Mix • Napa, CA

SARGE • Mixed Breed • North Adams, MA (opposite)

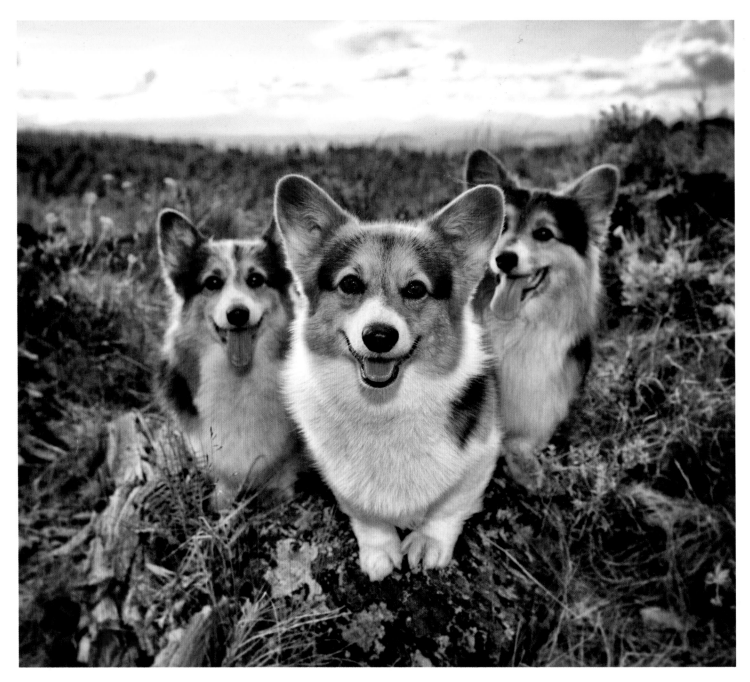

PAGER, TRYSTON & BROOK • *Corgis* • Bend, OR

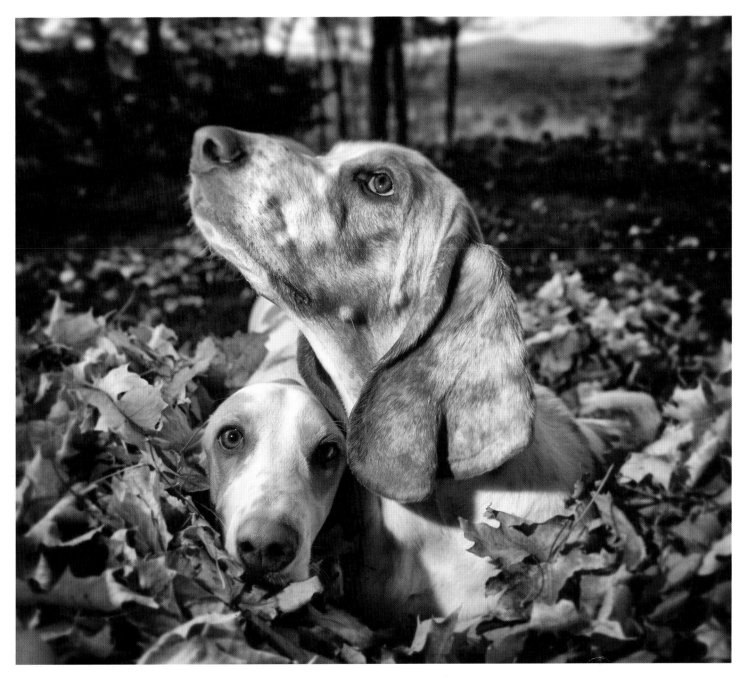

GOOGIE & IMPY • Bassett Hounds • Lenox, MA

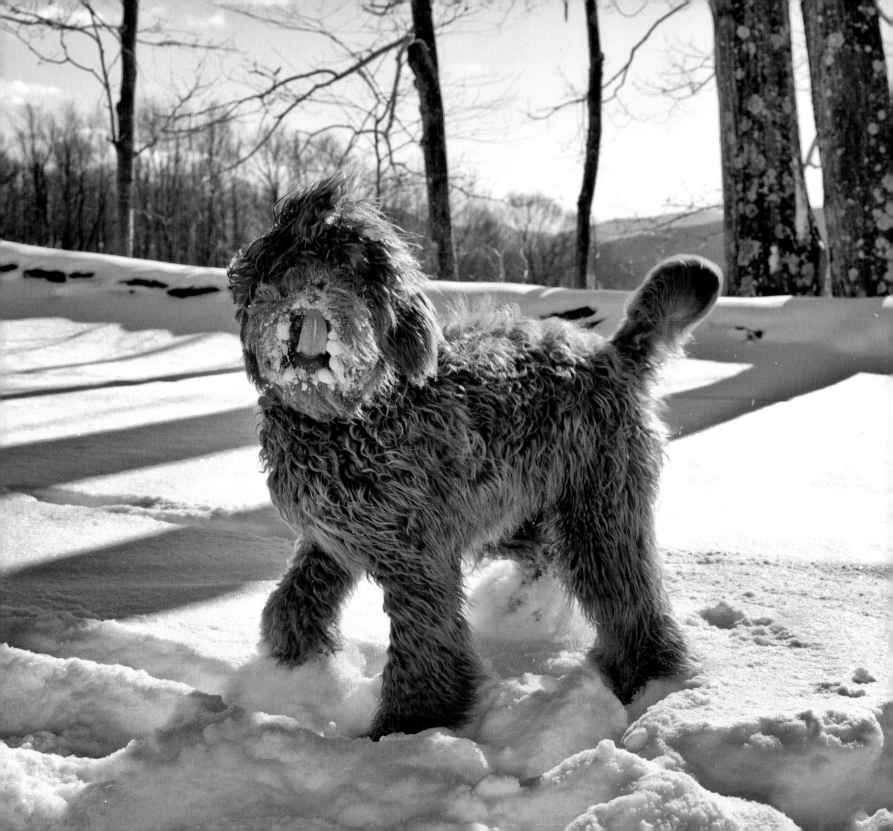

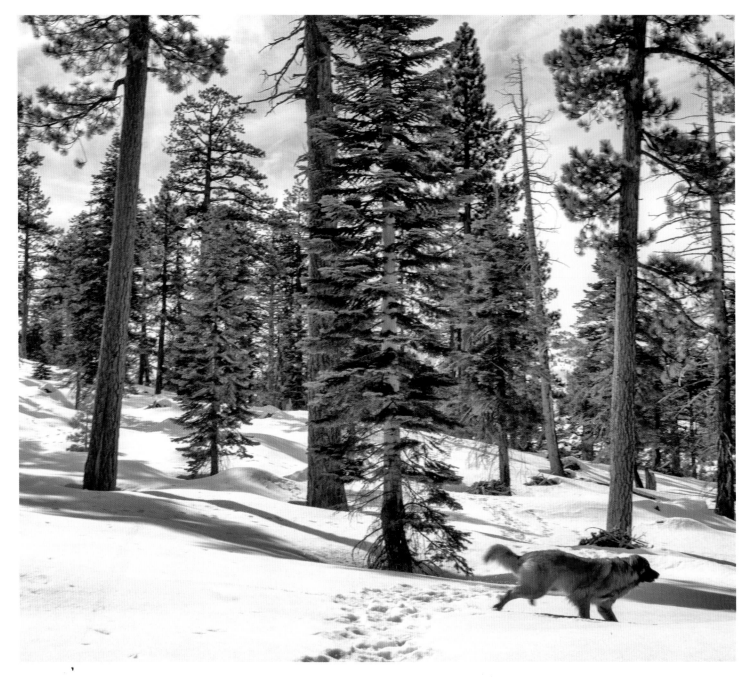

STELLA • Leonberger • South Lake Tahoe, CA

BOOMER • Labradoodle • Williamstown, MA (previous)

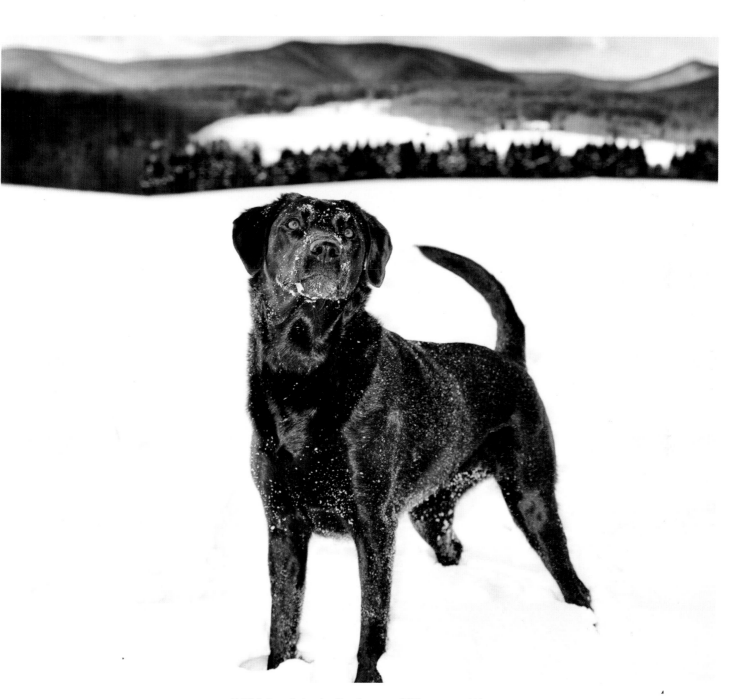

BELLA • Labrador Retriever • Williamstown, MA

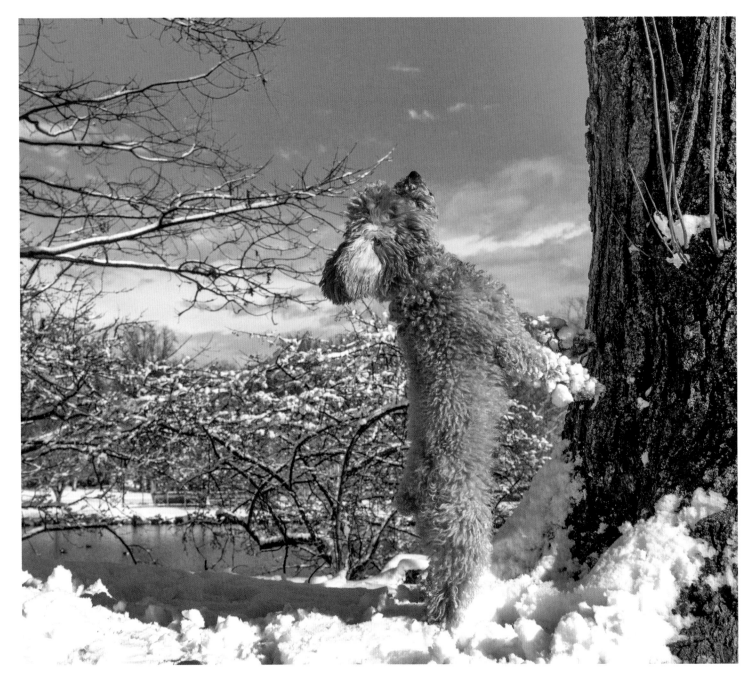

CHANCE • Cockapoo • Greenwich, CT

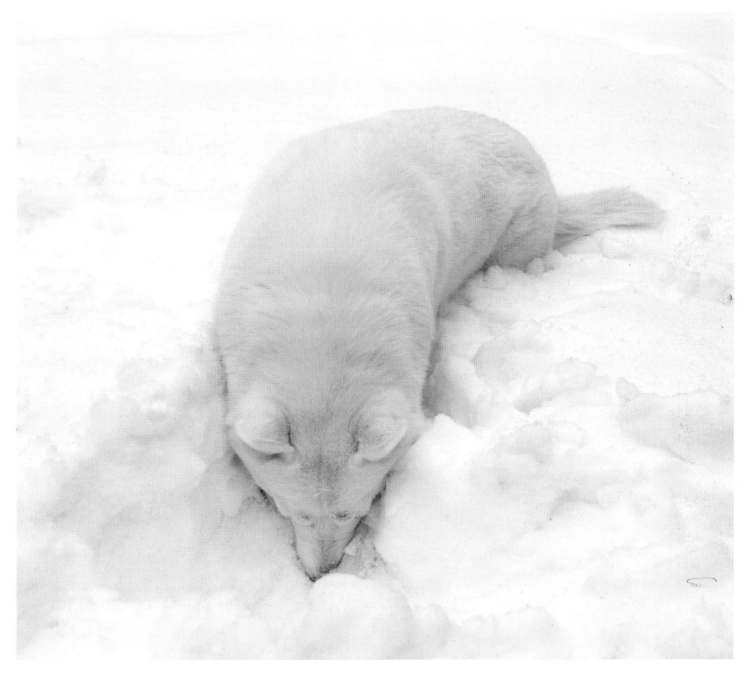

KYLIE • Siberian Husky • Vail, CO

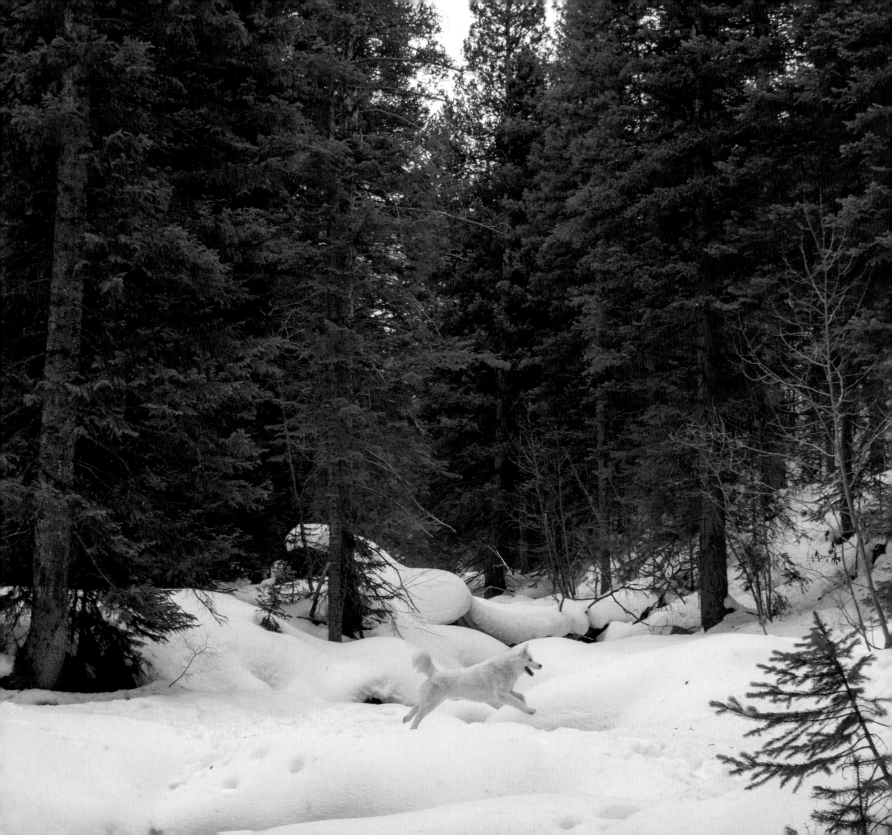

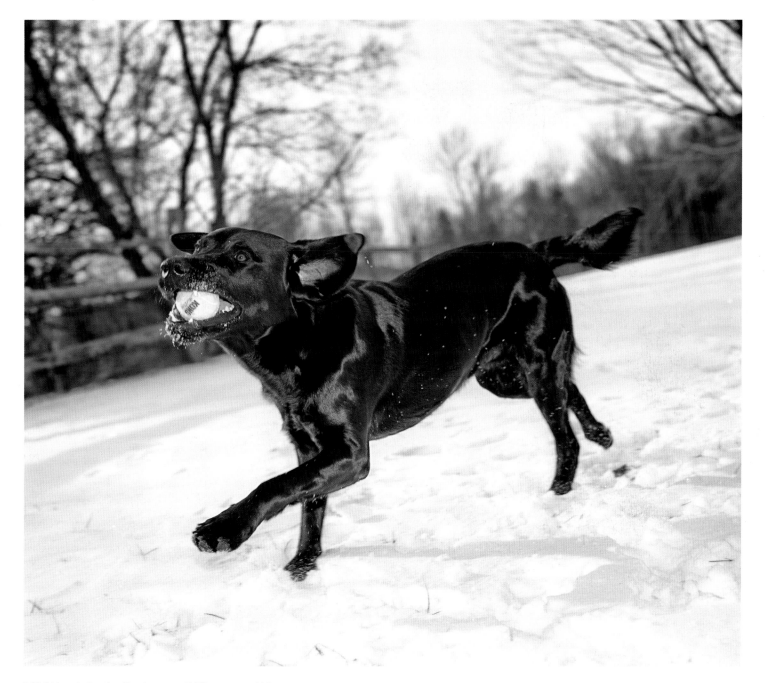

LILLY • Labrador Retriever • Williamstown, MA

JAKE • Siberian Husky • Vail, CO (opposite)

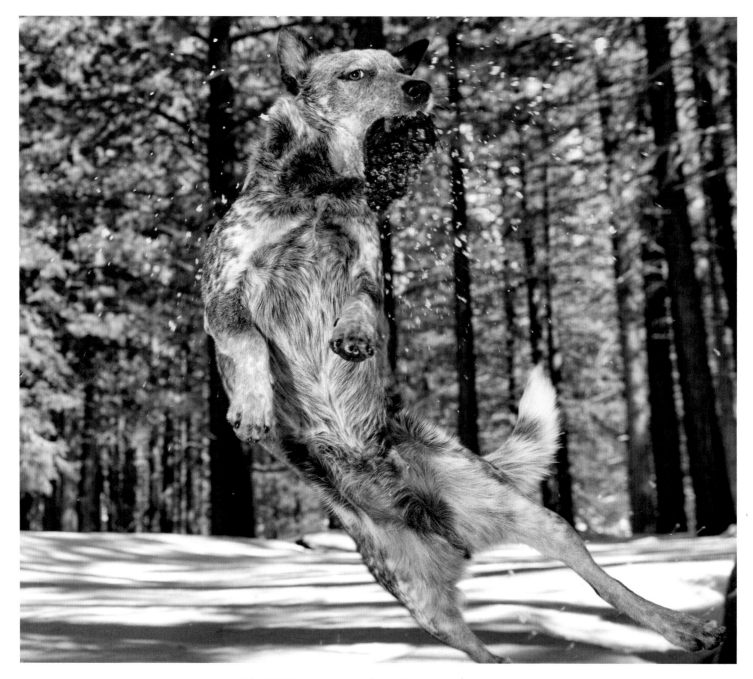

SANCHO • *Australian Cattle Dog* • Lake Tahoe, NV

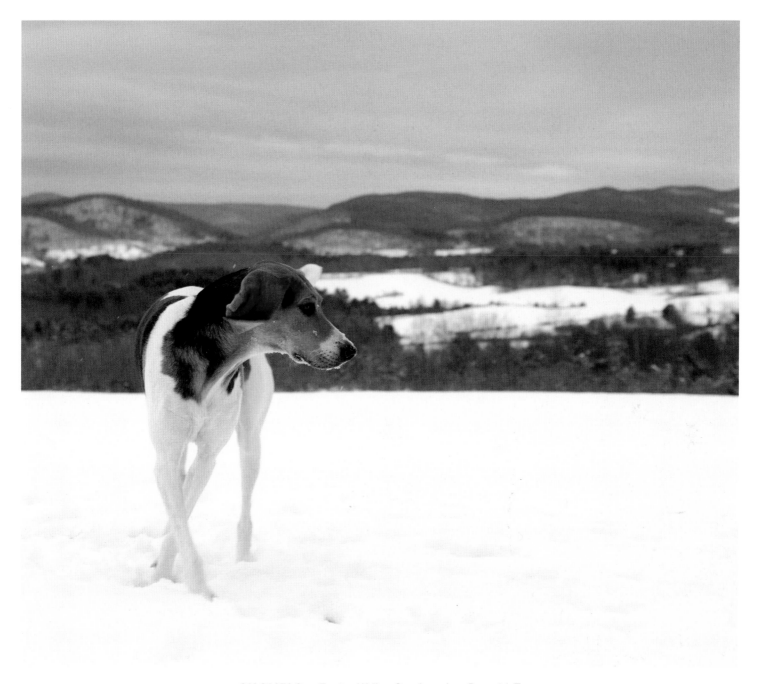

SHOVELS • Treeing Walker Coonhound • Pownal, VT

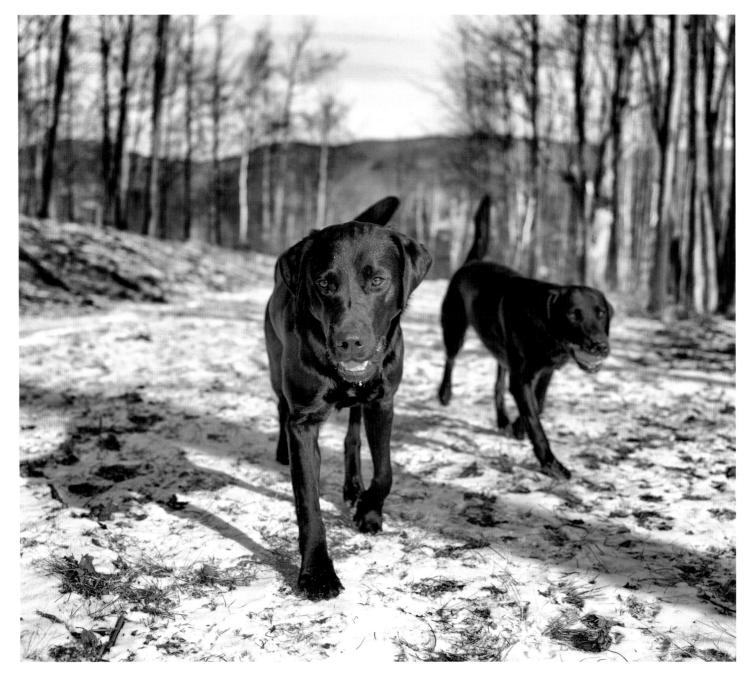

GUS & CASEY • Labrador Retrievers • Williamstown, MA

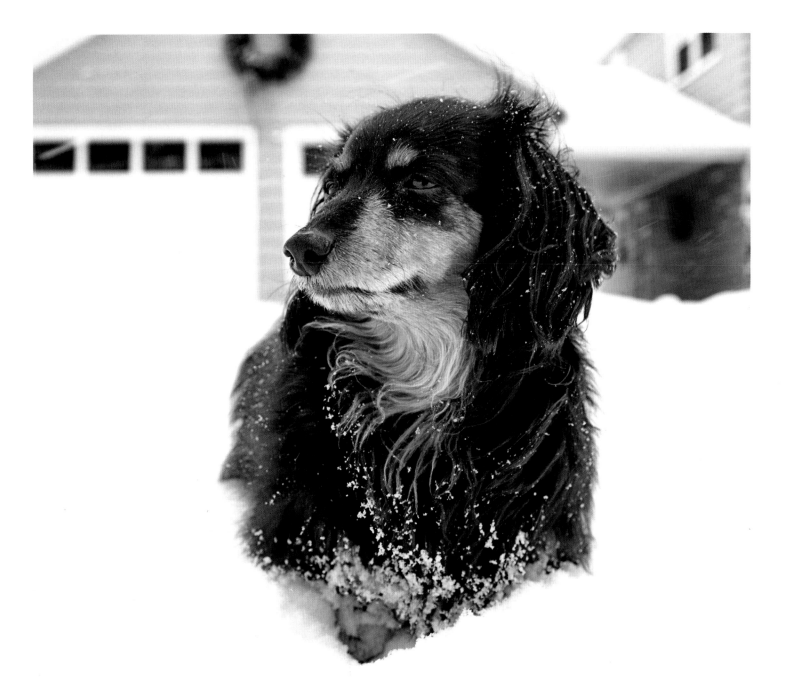

LILY • Dachshund • Williamstown, MA

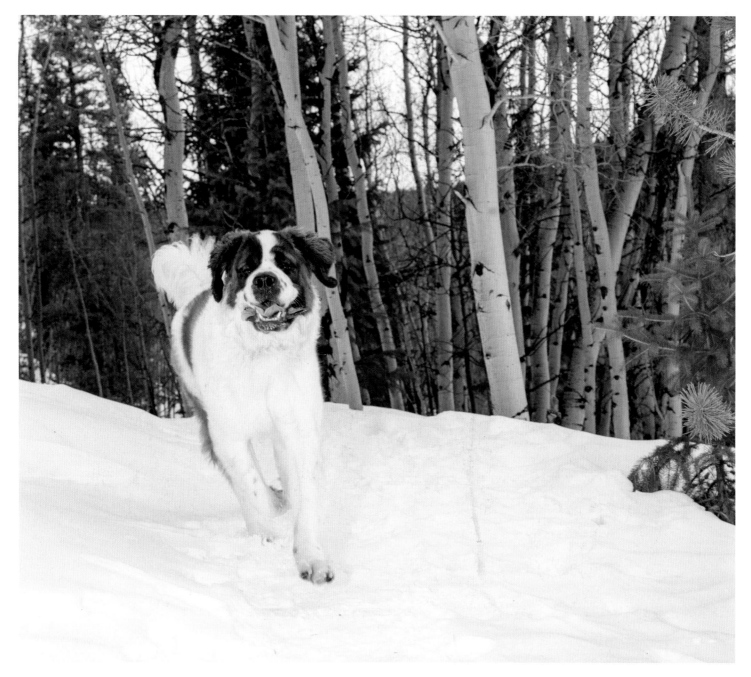

OLIVER • St. Bernard • Breckinridge, CO

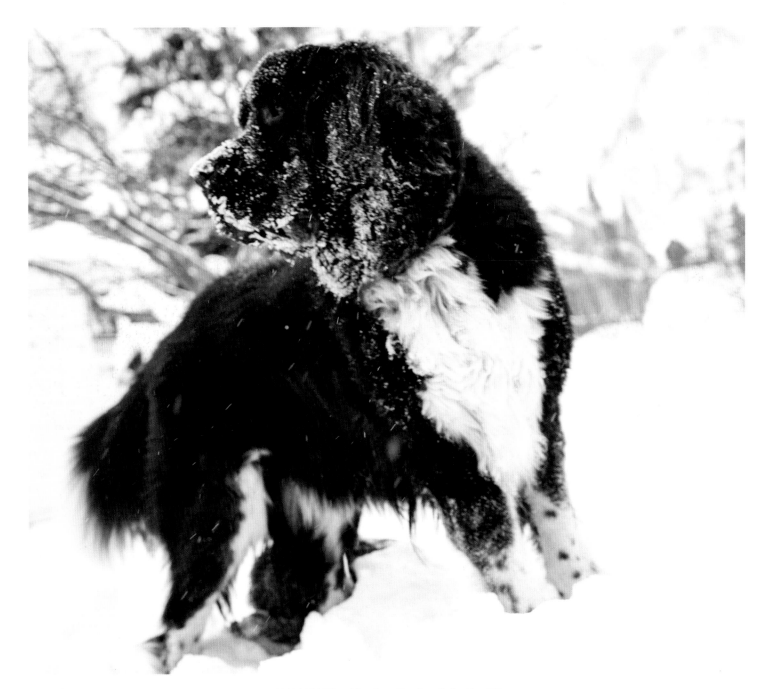

STANLEY • Newfoundland • Telluride, CO

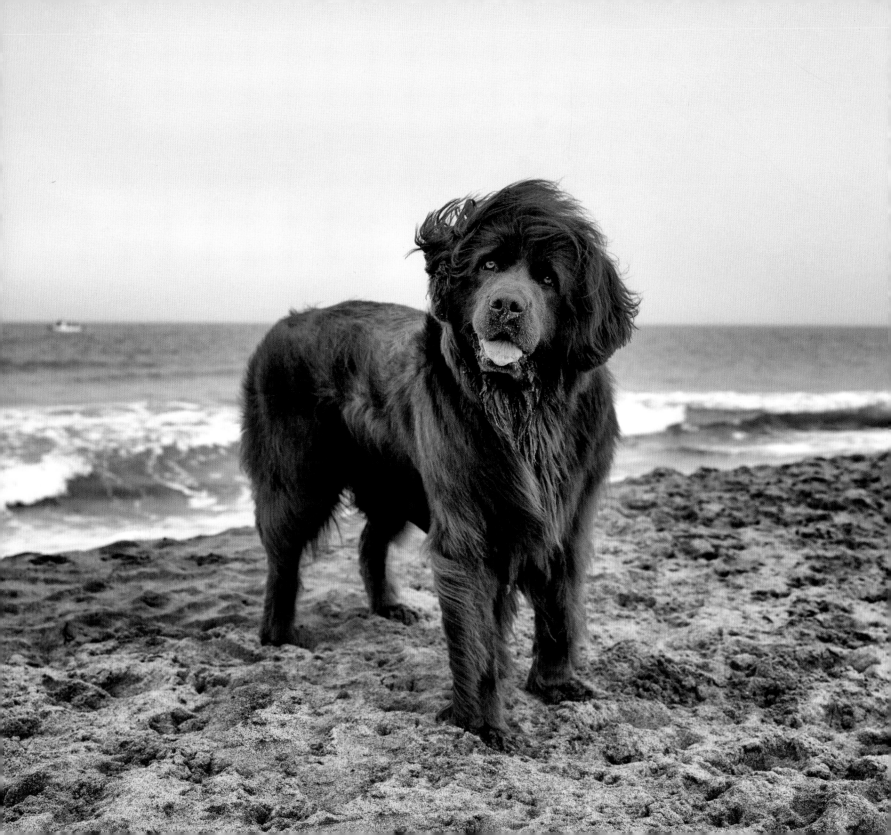

LOLA • **Great Dane** • Edwards, CO

JELLY • **Newfoundland** • San Francisco, CA (opposite)

BOOKA • Blue Heeler Mixed Breed • Silverthorne, CO

PIPER & MACK • Labrador Retrievers • Edwards, CO

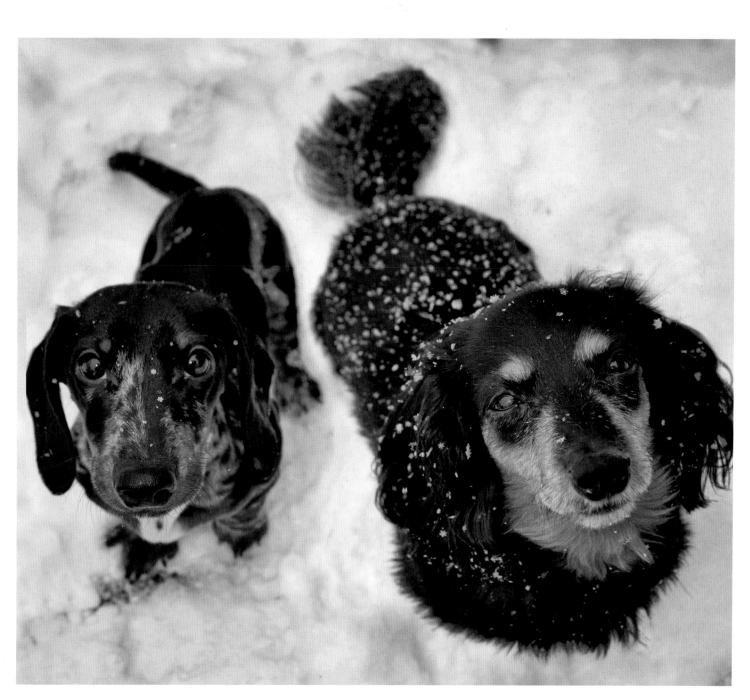

BENNY & LILY • Dachshunds • Williamstown, MA

CHARLEY & CAMERYN • Mixed Breeds • Edwards, CO (opposite)

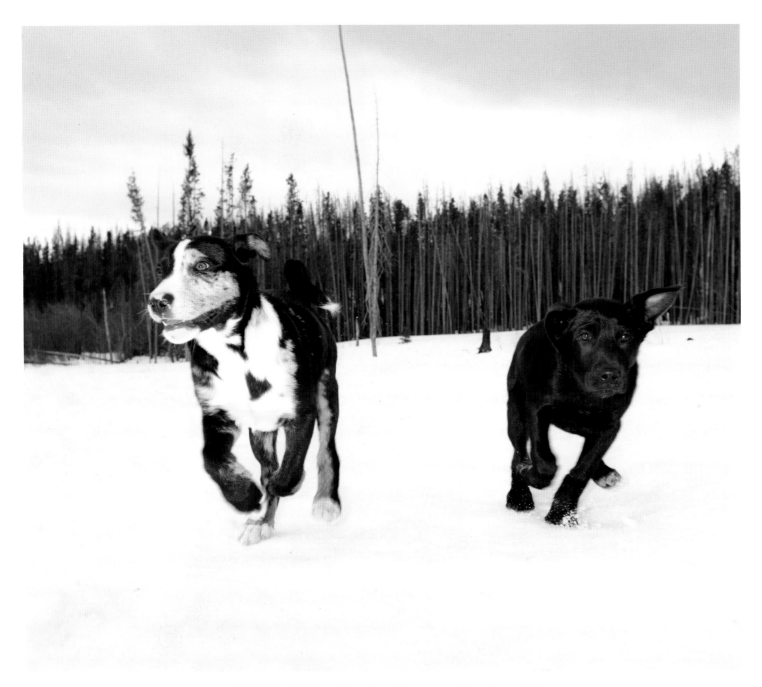

LUCKY & PAWS • **Mixed Breed Puppies** • Silverthorne, CO

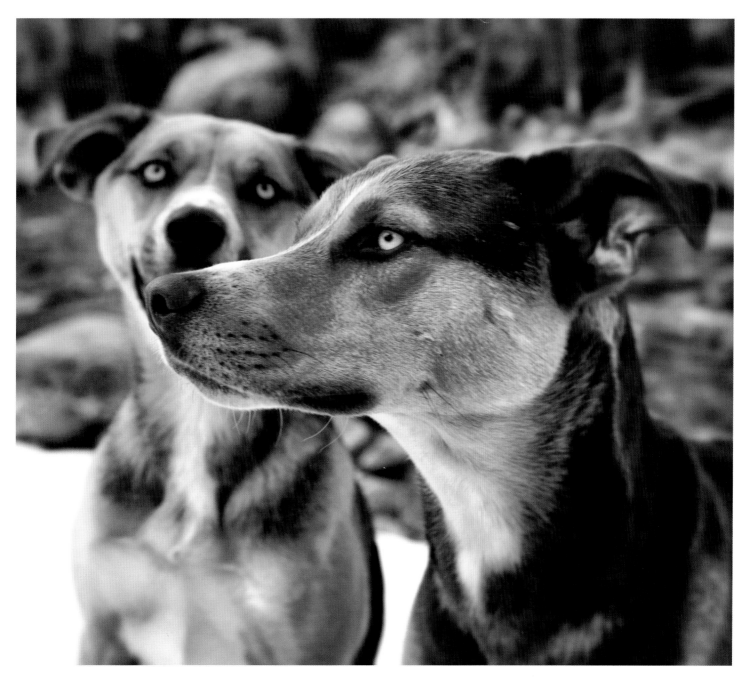

CLINTON & CRAWFORD • *Mixed Breeds* • Edwards, CO

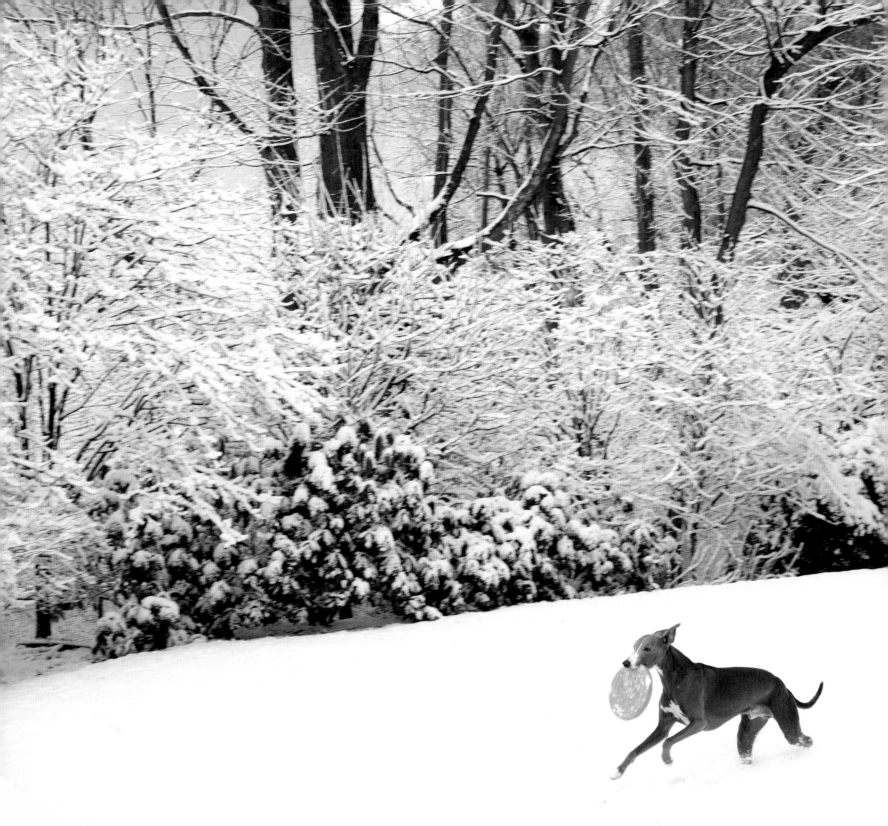

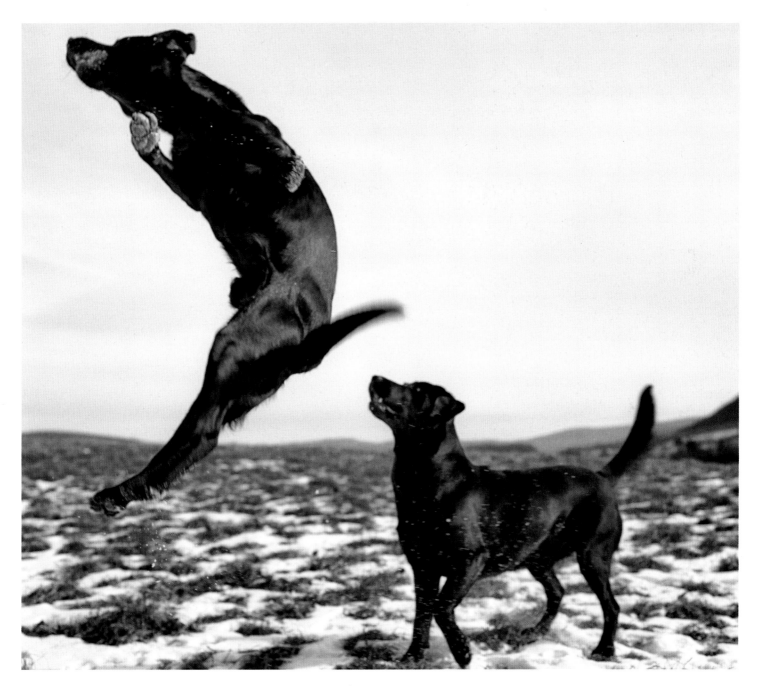

ASTOR & HOMER • Labrador Retrievers • Williamstown, MA

SMOKEY • Whippet • Greenwich, CT (opposite)

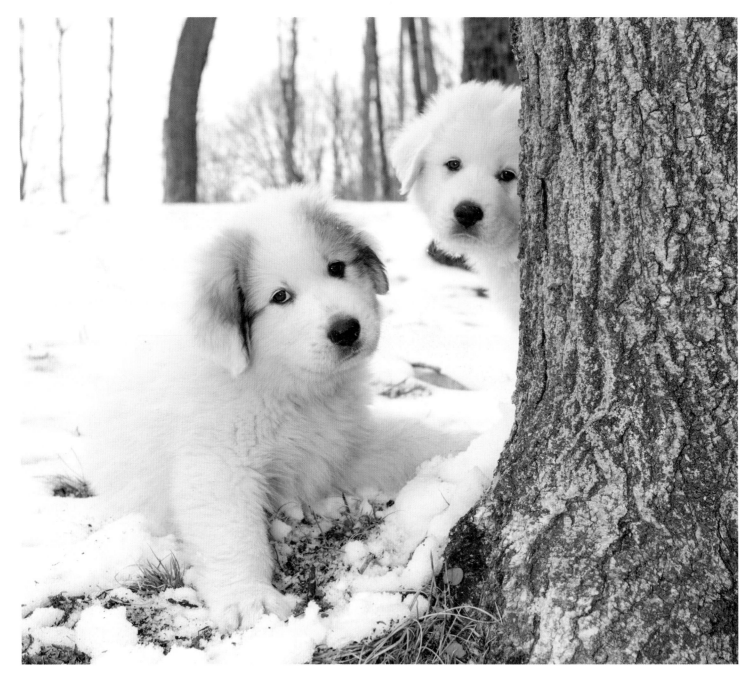

JUNIOR & FALKOR • Great Pyrenees Puppies • Clarksburg, MA

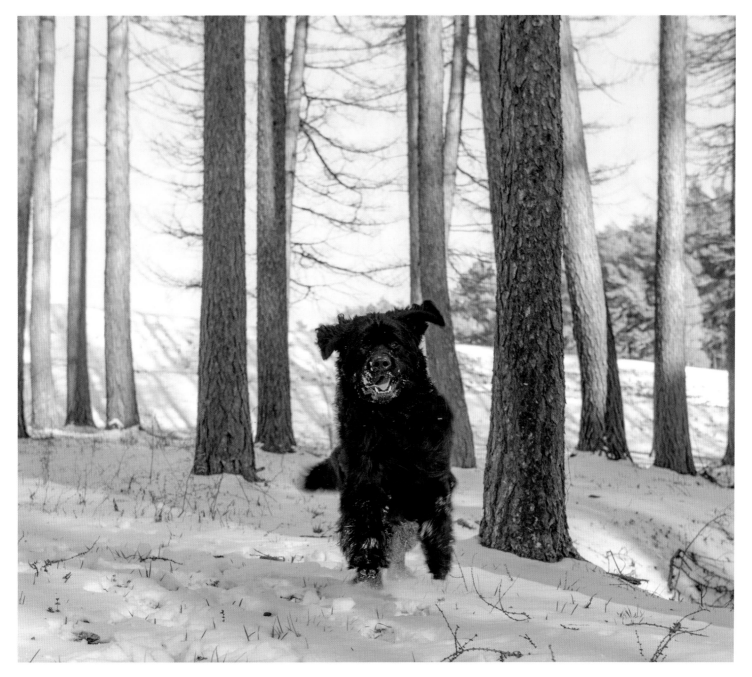

WALT • *Newfoundland* • Williamstown, MA

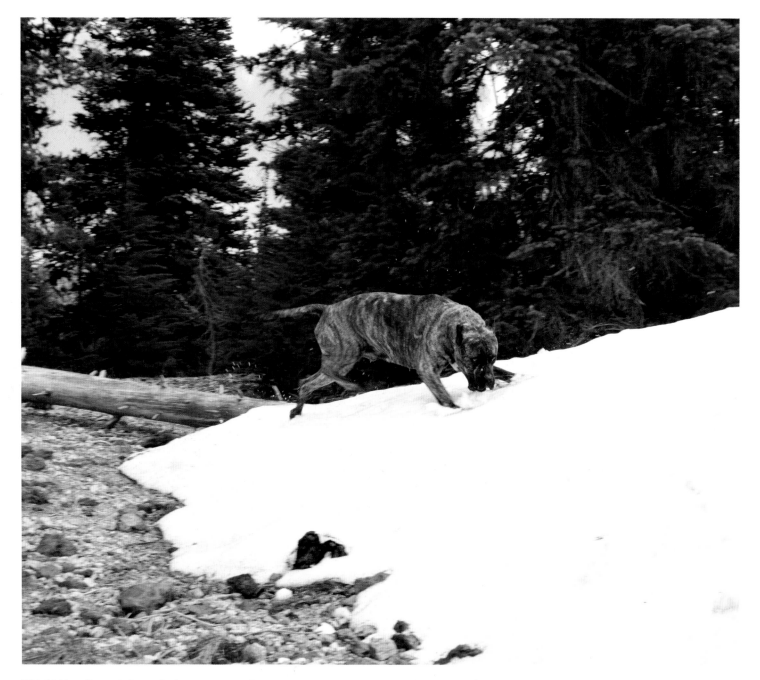

WARLY • Perro de Presa Canario • Bend, OR

SAVANNAH • Mixed Breed • Adams, MA (opposite)

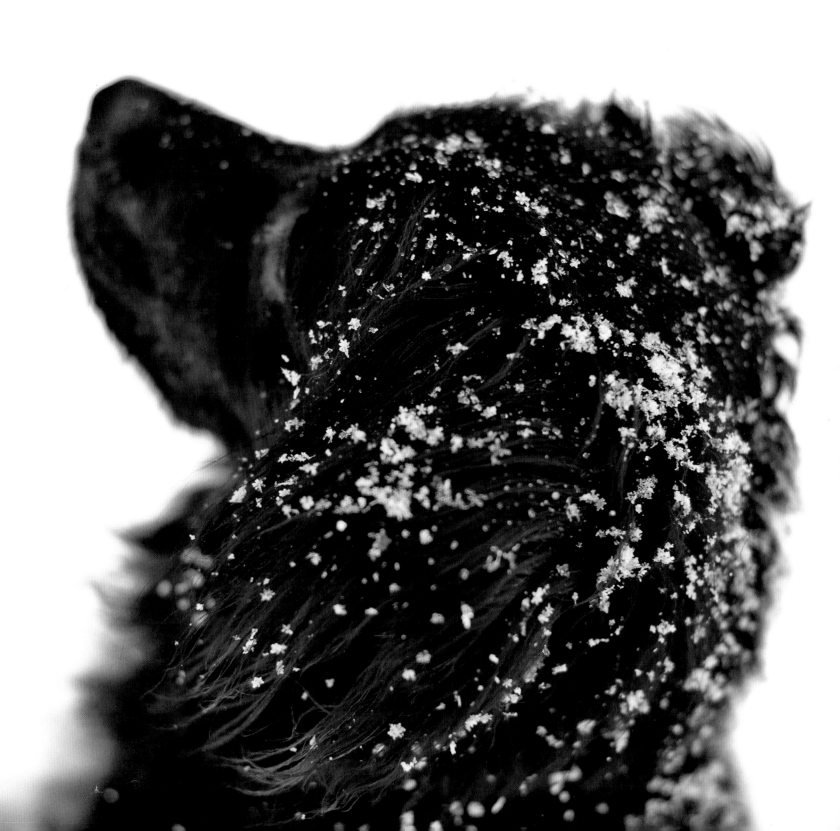

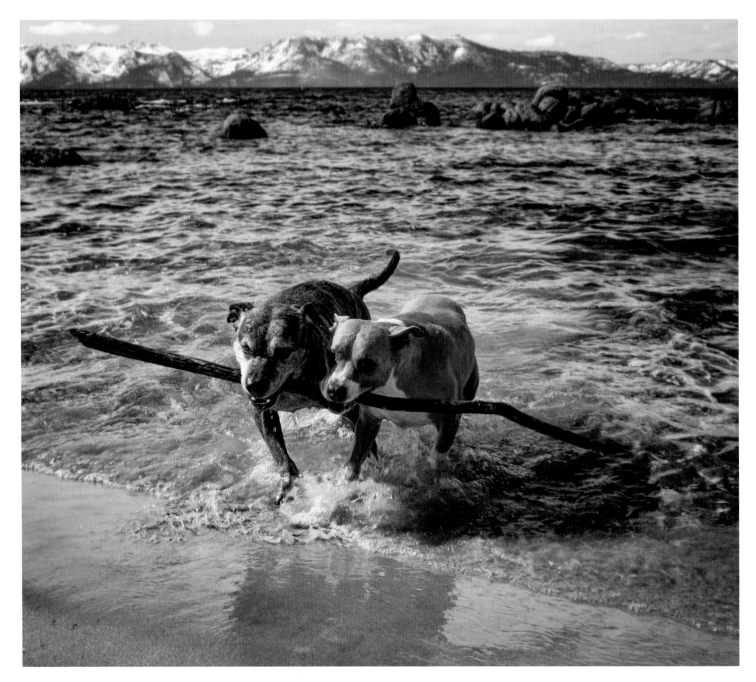

MALCOM & PLANEY • Pit Bull Mixes • Lake Tahoe, NV

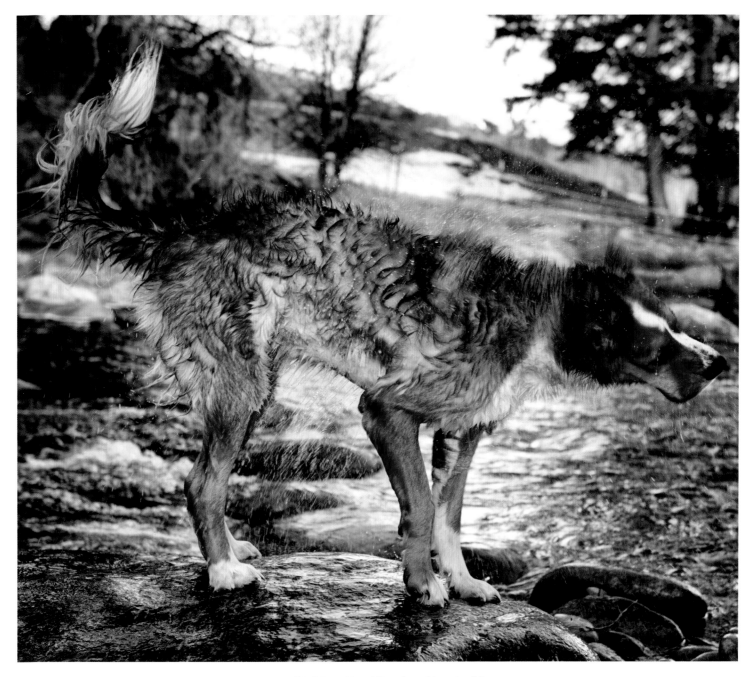

AUGUST • Mixed Breed • Edwards, CO